General Editor
David Piper

Dürer

Every Painting

Peter Strieder

Director of the Gallery of Painting, German National Museum, Nuremberg

translated by Hano Johannsen

NEW YORK

Foreword by the General Editor

Several factors have made possible the phenomenal surge of interest in art in the twentieth century: notably the growth of museums, the increase of leisure, the speed and relative ease of modern travel, and not least the extraordinary expansion and refinement of techniques of reproduction of works of art, from the ubiquitous colour postcards, cheap popular books of colour plates, to film and television. A basic need – for the general art public, as for specialized students, academic libraries, the art trade – is for accessible, reliable, comprehensive accounts of the works of the individual great masters of painting; this has not been met since the demise before 1939 of the famous German series, *Klassiker der Kunst*; when such accounts do appear, in the shape of full *catalogues raisonnés*, they are vast in price as in size, and beyond the reach of most individual pockets and the capacity of most private bookshelves.

The aim of the present series is to provide an up-to-date equivalent of the *Klassiker* for the now enormously enlarged public interested in art. Each volume (or volumes, where the quantity of work to be reproduced cannot be contained in a single one) catalogues and illustrates chronologically the complete paintings of the artist concerned. The catalogues reflect as far as possible a consensus of current expert opinion about the status of each picture; in the nature of things, consensus has yet to be reached on many points, and no one professionally involved in the study of art-history would ever be so rash as to claim definitiveness. Within the bounds of human fallibility, however, every effort has been made to achieve both comprehensiveness and factual accuracy, while the quality of reproduction aimed at is the highest possible in this price range, and includes, of course, colour. Every effort has also been made to hold the price down to the lowest possible level, so that these volumes may stay within the reach not only of libraries, but of the individual student and lover of great painting, so that they may gradually accumulate their own 'Museum without Walls'. The introductions, written by acknowledged authorities, summarize the life and works of the artists, while the illustrations place in perspective the complete story of the development of each painter's genius through his career.

David Piper

Introduction

Albrecht Dürer was the first artist to make an impression on the German public through his published writings. Sayings attributed to Dürer were presented as fundamental truths by leading teachers such as Philipp Melanchthon and were treated in much the same way as the anecdotes and writings of classical authors of the past.

But what Dürer was aiming to do and the way he set about achieving it was felt to be entirely new. He placed himself outside the social and artistic tradition of his home town of Nuremberg. Yet he was not a revolutionary demolishing everything that had gone before. He absorbed the rich inheritance of late Gothic art and its theoretical concepts and led his generation not only into a new exploration of different kinds of art but into a new self-awareness.

At the age of fourteen, when he was learning to be a goldsmith in his father's workshop, the boy Dürer felt compelled to take up a silverpoint and draw his own face in front of a mirror (see p. 4, top left). Whether his father's *Self-Portrait* served as a model (p. 8, top) or whether the portrait was finished by him at a later date is not important.

Albrecht Dürer, the elder, must have been an unusual man for he left behind a family diary in which he recorded details of his forefathers, his way of life and the birth and death of his eighteen children. The son carried on this diary until 1523. The diary is preserved in a seventeenth-century copy.

The grandfather of Albrecht Dürer came from a Hungarian village called Ajtos (which translated means 'door') from which the family name 'Dürer' was taken. Thence he moved to Gyula, the main town of the Kemitas Bekes, to work as a goldsmith. His son Albrecht took up the craft and left Hungary to complete his training. The second son was described as being a priest in 1461 in Gross Wardein in Hungary. The family's origination from Ajtos is retained in its arms (see p. 7) which show an open door and were probably used by old Albrecht himself.

The diary tells us nothing about the family's nationality but the emigration of Albrecht, the elder, to Germany suggests that the family belonged to the German craftsmen who were settled in the Gross Wardein area. From Germany Albrecht, the elder, travelled to the Netherlands so as to work with the 'great artists'. He stayed there for some time before settling in Nuremberg. After twelve years he married the daughter of his master Hieronymus Holper and in the same year (1467) became a citizen of the town.

Albrecht, the younger, the fourth child, was born on 21 May 1471 inheriting from both parents the craft skills of manual dexterity and ability for precision work. The man who made his way from an obscure Hungarian town to the European centre for goldsmiths clearly showed that he had his own plans for his artistic development. His son who joined him as an apprentice similarly had ideas of his own and decided to be a painter rather than a goldsmith. On 30 November 1486 he was apprenticed to the painter Michael Wolgemut who lived close to his parents' house. His father's activities had a significant influence on young Albrecht for he recalled conversations in some detail in what is otherwise a diary with only brief entries. Dürer's relationship with his father is also captured by the two portraits he painted. Even the existence of these portraits is without parallel. The earlier painting of 1490 (No. 2A/B) was completed when he finished his apprenticeship with Wolgemut and before he set off on his travels. On the reverse are the Dürer-Holper arms and it is probable that this picture was part of a diptych. In the second portrait (No. 43) of 1497 the father was seventy years old. In this picture Dürer not only applied the painting skills he had acquired but managed, by virtue of the format, to represent from head to waist a successful master craftsman who was an honoured and respected citizen. The wrinkled face suggests concern and sorrow caused by the early death of fifteen children. After the death of his father in 1514 Dürer looked after his mother and shortly

3

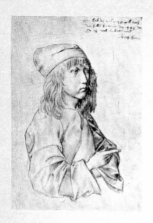

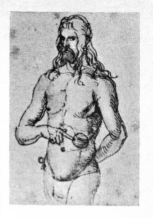

before she died he produced an excellent charcoal drawing of her (see p. 8).

In the course of the travels Dürer made as a young journeyman artist after his apprenticeship he went to the Upper Rhine after he had probably previously visited the Netherlands. Examples of his work at this time can be found in the illustrations printed by the Basel publishers and in the Konrad Imhoff collection in Nuremberg – the portrait of the Strasbourg teacher and his wife. It is possible that he also worked on a Dominican altarpiece.

The self-portrait on parchment (No. 3) shows Dürer at the end of his apprenticeship. It is a picture of an earnest, young and well-dressed man wearing a chic tasselled cap. The colours are restrained. The background is almost black and the garments are painted in predominantly grey tones: the most colourful feature is the red cap.

In 1494 Dürer's father asked his son to return to Nuremberg to marry Agnes Frey, the daughter of a coppersmith. The union was socially advantageous since the resourceful Hans Frey held various municipal offices and was related to a Nuremberg patrician family through his wife. Dürer left Nuremberg again in the autumn: this time his travels took him across the Alps to Venice. Although it was not unusual for a young Nuremberg trader to stay for a while in the business capital of the Adriatic, it was at that time unique for a German artist to do so. What persuaded Dürer to set off for Italy to develop his skills and widen his experience can no longer be

Left: Self-Portrait as a boy. *Silverpoint on toned paper (27.5 × 19.6, 1484; Vienna, Graphische Sammlung Albertina).* Above: Dürer as a sick man. *Pen and watercolour (11.8 × 10.8, c.1512–13; Bremen, Kunsthalle Bremen).*

established. However, it is certain that he was influenced by the humanist writers of Nuremberg, Basel and Strasbourg who had re-discovered the classics. It is also possible that he came across copper engravings by Andrea Mantegna in Nuremberg. Probably he was stimulated by a variety of influences and decided that he had to make direct personal contact with Italian art.

On his journey south to Venice he painted water-colours of key places along his route. They are the first watercolours in German art and record specific locations (12d, 13d 18-27d). These studies reached the public only in the form of copper engravings. In the water-colours Dürer showed that he was well ahead of his time in the way he used light and colour. Earlier in the summer of 1494, if not in 1490 before setting off on his travels, Dürer had painted a number of views around Nuremberg (Nos. 6d, 7d).

Only a few of the drawings he produced during his stay in Venice survive. There are detailed copies of local masters (No. 17d), studies of Venetian costumes and drawings of female models. Dürer learnt a great deal from his contact with Italy whose influence can be seen in the many works he produced after his return home in the late spring. On his return he concentrated on woodcuts and copper engrav-

ings and these marked the beginning of his international acclaim. They far exceeded in number the paintings he produced at that time.

The workshop which Dürer opened on his return to Nuremberg from Venice was in sharp contrast to the large-scale operations practised by his teacher Michael Wolgemut. In particular he lacked the facilities for producing the large wall altars on which painters and sculptors combined their skills. Those commissions for altarpieces which Dürer did accept, such as for the Paumgärtner family (73 A-C), c.1502, or for the Frankfurt trader Jakob Heller in 1507, included a central painted panel in contrast to the Nuremberg tradition. The central panel, now lost, of the Heller commission for the Dominican Church in Frankfurt showed the Assumption of the Virgin and was the only part of the altarpiece to be painted entirely by Dürer himself. The wings of the altarpiece, on the other hand, were produced in his workshop as his letters to Heller indicate (No. 150).

Dürer's early works include a number of portraits of important personalities. The earliest was of Frederick the Wise, Elector of Saxony, who stayed in Nuremberg in 1496 (No. 37). There followed members of the important Tucher family (Nos. 54A/B, 55) who were merchants and the young Oswolt Krel (No. 53A-C), representative of the large Ravensburger merchant house. This portrait was regarded by Dürer as one of his most important. He felt he had captured the sitter's personality and characteristics so well that he remarked 'the painting records the air and manner of the person even after his death'.

Dürer had already shown in his first painted portrait – of his father, 1490 (No. 2A/B) – that a painting can record the external shape and features of a person and at the same time can reflect his whole personality. Two rather different self-portraits painted within two years of each other show us how Dürer saw himself during the period when he was rapidly developing his artistic talent. In the c.1498 portrait (No. 48) the doorway and arch in the background, and a window on the right, give the half-length figure a feeling of a solidity. The clothing has style and is proudly worn, indicating Dürer's new self-awareness as an artist. Subdued colours such as light brown, grey and white predominate and, with

the contrast of intense black, show Dürer's skills as a painter. Through the window we can see the kind of landscape with which he experimented in watercolour following his Italian journey.

The image of a painter comes through more clearly in the portrait which he painted in 1500 almost certainly to mark the beginning of the second half of the millenium (No. 59). The picture presents a dignified figure looking straight at us and echoes the majesty with which pictures of Christ were often presented. The inscription in Latin – the language of the church and the Humanists – contrasts with the strong colours of the painting. Convinced of the holy origin of art which depends on divine inspiration Dürer does not shy away from presenting himself as a Christlike figure.

Dürer captured the essential features of different species of animals or plants in the many studies which he produced at the beginning of the sixteenth century. The famous watercolour of the hare (for which Dürer may have used a stuffed hare) manages to reflect all the characteristics which we associate with that animal (No. 72d). Similarly *The large piece of turf* indicates how carefully he observed a clump of meadow grasses (77d). The grasses and plants are shown as an integrated group and not as separate botanical specimens. To date the attribution of a number of studies of individual plants, some on paper, others on parchment, which have long been linked with Dürer's name, is still not certain (82d, 83d, 84d, 85d, 86d).

For the traditional Christian themes Dürer now adopted a variety of techniques, including woodcut, for his series of the *Apocalypse*, and the *Great Passion, Little Passion* and *Life of the Virgin*; copper engraving for the single plates of *St Eustace* and *Adam and Eve*, among others; and painting in oil or watercolour for a variety of themes, including a number of pictures of the Virgin Mary (46B, 47, 50A, 75, 76d). The centre panel of the Paumgärtner family altarpiece (No. 73A-C) shows the Nativity with the child Jesus as the new light of the world. Roman ruins and arches provide the background and frame the group of figures including the shepherds who are hurrying to see for themselves what the good news is all

about. The small-scale figures of the donors and their family are traditionally included in the picture and shown worshipping the holy child. In contrast the wing pictures depict two full-length figures of members of the family as St George and St Eustace. This trespass of the profane into a sacred theme was criticized by the moralists of the day.

A few years later in 1504, Dürer painted *The Adoration of the Magi* (No. 90) in a wider format; in all probability this was commissioned by Frederick the Wise. Nothing is known about the wings for this picture and it is possible that both painter and patron agreed not to produce a traditional type of altar painting. Two wing panels which were also produced in 1504, showing two standing saints and Job suffering ridicule, are most unusual scenes for a triptych (No. 91 A-D).

While Dürer was fascinated by classical mythology after his return from Italy only one painting on this theme survives. Some authorities consider that the strange painting dated 1500 and showing the almost naked Hercules with bow and arrow poised to kill the Stymphalian birds was part of a wall decoration prepared for Frederick the Wise's castle in Wittenberg (No. 57).

When Dürer visited Venice for the second time in 1505 he was no longer a student and was able to show many Italian artists that he now had something to offer them. In particular, his graphic work had become well known and a series of his engravings and woodcuts were copied both north and south of the Alps soon after they appeared. While his masterful skills as an engraver were recognized, the general feeling was that the German artist still had a lot to learn about painting.

We know that the Venetian painters felt this way from the ten surviving letters which Dürer wrote to his friend Willibald Pirckheimer in Nuremberg. In these letters we learn also of the major commission which the German traders in Venice gave to Dürer for their Church of St Bartolomeo. The theme, the *Feast of the Rose Garlands* which pays homage to the Virgin, was a favourite one with the Dominicans. The Virgin holds the child in her right arm: together with St Dominic they are handing out rose garlands to the spiritual and temporal leaders (No. 93).

The pyramidal composition adopts the Italian style. In the depiction of the participants Dürer confirms his ability to capture individual characteristics. In the background landscape he gives the Italians an insight into the Germanic view of nature; and with his brilliant and careful use of colour which reflects the character of the numen, he answered the Venetians' claim that he was not really a painter.

Dürer included himself in the picture: he is holding a piece of paper which states that he took only five months to complete the picture. Compared with this opus *'quinque mestri spatio'* he inscribed his picture *Christ among the doctors* as an opus *'quinque dierum'* (of five days) (No. 94): in both cases he does not include the time taken for the preliminary drawings he made. In *Christ among the doctors* the central figure of Jesus as a boy is surrounded by several men each very different in character and age. The position of the hands is particularly interesting – some are at rest, others are active. The new Italian influences are clear from this picture about which he wrote to Pirckheimer that it was a work 'the like of which I have never painted before'. In part it caricatures Leonardo da Vinci's representation of medieval ugliness and the kind of half-length figures produced by Giovanni Bellini and his associates. On the other hand, Dürer's painting has a certain affinity with the later work of Giorgione.

Dürer was in demand as a portrait artist during his stay in Venice. Four paintings from this period have survived (Nos. 92, 96–98). In a letter to Pirckheimer he complains that he could have had many more commissions had he not been committed to a picture for the German trading community. That he had now mastered the art of painting what Erasmus von Rotterdam called the 'soul of a person' is clearly indicated by the almost completed picture of a young lady (No. 92) which captures the personality so well that it is reasonable to suppose that Dürer and the attractive young lady developed a close relationship. Dürer's Venetian portraits depict lay sitters and his use of colour, local costumes and hair styles give each painting a specific atmosphere.

His journey to Venice gave Dürer new insights into colour and on his return home he

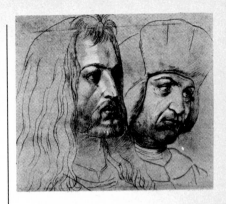

Above: *Albrecht Dürer's family's coat of arms. Woodcut (35.5 × 26.6, 1523).* Right: Albrecht Dürer and Willibald Pirckheimer. *Pencil drawing on paper, heightened with white, by Edward von Steinle (Leipzig, Museum der bildenden Künste).*

undertook more work using brush and palette. In 1507 he painted the panels of Adam and Eve (No. 101 A-B). The naked bodies of Adam and Eve are based on a copper engraving of 1504 when he made studies of the proportions of human bodies. Now Dürer is no longer concerned with ideal construction lines but with the beauty of the human body and he paints the figures against a dark background.

In the following years he completed his last large altar pictures. He devoted much time and care to painting the centre panel of the Jakob Heller triptych as the letters to his Frankfurt patron confirm. He was anxious that it should last for centuries but in fact it went up in flames. The painting is known from a seventeenth-century copy, which gives us some idea of the original composition and colour, and indicates that Dürer had based the painting on preliminary sketches and studies he had made in Italy.

The 1511 painting, *The Adoration of the Trinity* (No. 106), was commissioned by Matthias Landauer for the old people's hostel known as the House of the Twelve Brothers which he founded in Nuremberg in 1510: Dürer filled the space with holy figures and the city of God. Apart from the small solitary figure of the artist who is standing on the ground, all the figures are suspended in the air. The figures representing mankind kneel before God the father whose outstretched

arms support the cross on which his Son is crucified. The dove of the Holy Ghost flutters above. Groups of angels, saints and prophets surround the Trinity in a flood of light. Dürer designed a carved frame along Venetian lines for the panel which no longer required side shutters. The decoration of the frame with its large semi-circular top with a frieze below showing the Judgement combines Gothic and Renaissance features.

From now on Dürer's paintings concentrated on small devotional pictures usually dedicated to the Virgin (Nos. 115, 116, 123). Following the Reformation movement and the end of the large altar-painting era, Dürer devoted much energy to these small paintings.

Other commissions now occupied Dürer and his studio which was set up in 1509 in his Tiergärtnertor house. In 1512 Emperor Maximilian I set up projects aimed at self-glorification and gave various commissions to the Nuremberg painter. The two men probably met for the first time in the same year. Later in 1518 Dürer travelled with a delegation from his town to Augsburg and drew the Emperor who was attending the Diet. Maximilian died a few months later and the drawing formed the basis for a woodcut portrait – the first likeness that Dürer produced specifically for reproduction – and two paintings (Nos. 126, 127).

Dürer does not show the Emperor as a knight, as was the custom in former pictures. The pomegranate, the personal symbol of Maximilian, in his left hand, and the crest are the only indications of his high status. The dignity and pose of the sitter rather than

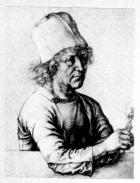

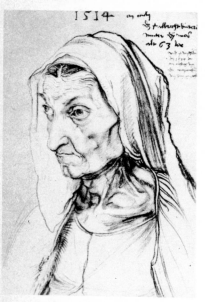

1514

Top: Albrecht Dürer the Elder: Self-Portrait. *Silverpoint on toned paper (28.4 × 21.2, c. 1484; Vienna, Graphische Sammlung Albertina).* Above: Albrecht Dürer's Mother. *Charcoal on paper (42.1 × 30.3, 1514; Berlin, Staatliche Museen Preussischer Kulturbesitz, Kupferstichkabinett.*

Opposite page: *Dürer's house in Nuremberg, acquired in 1509.* Below: *Memorial to Dürer in Nuremberg (by Christian Danial Rauch, 1828).*

symbols of power are used by Dürer to indicate that he is the all-powerful Emperor.

Although the actual woodcuts for the Triumphal Arch, Triumphal Procession and Maximilian's Triumphal Car were in part prepared by assistants from Dürer's sketches they all gave him scope for indulging in fantasy. He provided many of the detailed effects within an overall design supervised by the Emperor and his advisers. Dürer was, however, given a completely free hand to design and embellish Maximilian's prayer book for the knights of the Order of St George. The colourful drawings appear to have been produced effortlessly and spontaneously and follow the text freely. The margins of the Christian text are sometimes accompanied by mythological and secular ornaments.

Dürer had an earlier commission from the Nuremberg city fathers to paint two life-size pictures of Emperor Charlemagne and Sigismund (Nos. 110–111). They were required to honour the arrival of the Imperial insignia of Charlemagne which was kept in a house in the main market place of Nuremberg. On Sigismund's instructions the relics were shown to the people once a year. The city's records show that Dürer was paid for these pictures of the Emperors in 1513.

While in the employ of Maximilian I, Dürer painted a portrait of his former teacher Michael Wolgemut who, though now grown old, was still active (No. 117). It is another example of Dürer's close observation and empathy for his sitter. The head, in three-quarter profile, with a pronounced nose is set against a green background. The wrinkled neck appears to grow out of the brown fur garment which provides a firm, dark base. The brush pitilessly records all the signs of old age and makes the cheerless black stare of the eighty-two-year-old painter all the more dramatic. Dürer painted the picture for himself in 1516 as the inscription in the top right hand corner confirms: Wolgemut died three years later.

Dürer set off on his last major journey to the Netherlands in 1520 and stayed one whole year. Now fifty years old, he was still keen to meet people, see art collections, record his experiences and develop his skills. The journey was undertaken partly in order to obtain

from Maximilian I's successors payment of the life-long pension which the Emperor had granted to him. Dürer was delighted with the opportunity of seeing Netherlandish art of the past and present and with the recognition and acclaim he received from foreign artists. We have a record of his journey in the form of a diary and two sketch books – the pages of the latter are now in various collections. The diary records in detail the experiences he had on his travels. He proudly records the hospitality and recognition he received, the visits he paid to artists' studios and the old master paintings he saw. The sketch books record impressions of the countryside and the people seen through the eyes of a foreign visitor (Nos. 130d, 131d, 132d, 135d).

To help defray the costs of the journey, on which he was accompanied by his wife Agnes and a maid, he took along a large quantity of

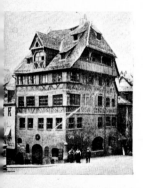

his own prints for sale and as payment in kind: he recorded them carefully in his diary. Since Dürer had no studio in Antwerp or Brussels he had to confine himself mainly to large charcoal drawings which could be completed at one session and were therefore particularly spontaneous and lifelike. Sometimes he managed to obtain studio facilities from local artists so that he could transfer the pictures onto wood. Two such portraits have survived (Nos. 133, 134) and he painted another of the fugitive King Christian II of Denmark. His diary records this and the expenditure he incurred for preparing the panel and grinding the colours with an apprentice painter called Bartholomew.

The portrait thought to be of the young trader Bernhard von Reesen of Danzig is particularly well-preserved (No. 134). It is difficult to identify the sitter with certainty since the hand holding the letter covers the family name which is usually included in such paintings of traders. The modelling of the face in tone is masterfully handled. The enormous beret which was fashionable at that time complements the fur collar but does not detract attention away from the startling face.

In Italy Dürer had developed the idea of compiling a handbook of painting to help train all artists. The preparatory work included numerous studies in proportion, which anticipated subsequent scientific methods of drawing the human body accurately. On his return from the Netherlands he put much effort into completing the handbook but he only managed to finish parts of the work. A significant section was completed by 1523 but was not printed until 1528, after Dürer's death. Entitled *Treatise on Human Proportions* it was based on his own personal experiences and includes detailed advice and sketches on geometrical formulae. Dürer also produced a handbook called *Introduction to the Art of Measurement with Compass and Ruler* which was intended as a background guide. The end of the book deals comprehensively with problems of perspective. Dürer's third theoretical treatise on art called *The Fortification of Cities, Castles and Towns* deals, as the introduction makes clear, with geometry and its practical applications to the threats of Turkish aggression.

Dürer's exposure to past and contemporary painters in the Netherlands led

him to resume his own work with colour which he had for some years neglected in order to concentrate on graphic work. The period following his return from the Netherlands saw dramatic changes in religious beliefs and worship, with doubts being cast on the value of devotional paintings and woodcuts. He must have felt that it was possible to capture the spirit of the age only in portraits which could now be reproduced in quantity using the new printing techniques.

The half-length portrait including the hands (No. 136) was typical of the Netherlandish style. The date 1524 on the *Portrait of an unknown man* is almost undecipherable but confirms that it was painted in Nuremberg although the use of an oak panel confirms its Netherlandish origins. No other portrait by Dürer gives such an intense impression of will power. The vitality of the personality and the large, angled beret threaten to force the frame apart. Attempts to identify the sitter have proved futile but he may be one of the delegates who attended the Nuremberg Diet in 1522–3. It is also possible that it was not strictly speaking a portrait at all but rather an ideal portrayal intended to represent Willibald Pirckheimer as the spirit of Renaissance man.

The two portraits of Nuremberg senators, Hieronymus Holzschuher and Jakob Muffel (Nos. 138, 139) considerably enhanced Dürer's reputation as a painter. The two sitters made no significant contribution to the political life of the city and their preservation for posterity depends on Dürer's paintings. In the Holzschuher portrait the position of the eyes, the strands of hair on the forehead and the deep furrows of the face suggest an irascible temperament. In execution this splendidly preserved picture indicates a considerable shift away from the soft colours Dürer used in the Netherlandish portraits. Every hair is painted with great care yet the picture makes a unified whole. Compared with the Holzschuher head, the portrait of Jakob Muffel seems bare. The structure of the skull can be discerned under the taut skin.

Sketches which Dürer made after his return from the Netherlands – single figures and studies for compositions – confirm that he had ideas for a large, religious painting of the Virgin surrounded by a heavenly throng. The style revives the old-fashioned Italian iconographical type of the Catholic *sacra conversazione*. We do not know who commissioned the painting which was never completed. It seems probable that the theme was no longer appropriate for the religious atmosphere then prevailing in Nuremberg.

In 1525 the city council decided to adopt the Lutheran cause, to change the form of religious services, to abolish the day of remembrance for the dead and to dissolve the monasteries. Dürer had sympathy with the Lutheran and Reformation movement and had belonged to the circle connected with Johann von Staupitz who held a theological chair at Wittenberg. Nevertheless as an artist who in his writings confirmed a strong relationship between art and religion, he was against any kind of suppression of art or science on religious grounds. This is confirmed by the text at the bottom of his last major work, *The 'Four Apostles'* (No. 140 A-B). Artistically the standing figures of John, Peter, Paul and Mark hark back to Venetian memorial paintings. On the other hand, the boldness of their presence and the large areas of colour for John's bright crimson robe and Paul's cool blue mantel with deep folds look back to German Gothic sculpture.

He offered the two panels to the Nuremberg City Council as a present and in so doing determined that they should be housed in the Town Hall. Dürer appended a text to the paintings which was intended specifically as a warning to the city fathers. 'All worldly rulers in these dangerous times should give heed that they are not misguided about the word of God. God will have nothing added or taken away from his word.' This warning was aimed at the secular rulers who had taken over the authority of the church and applied it to art and artistic development.

Dürer died so suddenly, on 6 April 1528, that his friends were unable to see him before he passed away. Willibald Pirckheimer composed an elegy and had his grave in St John's cemetery inscribed modestly with a few words which sum up Dürer's works: '*Quicquid Alberti Düreris mortale fuit, sub hoc conditur tumolo*' (That part of Albrecht Dürer which was mortal lies beneath this stone.)

Catalogue of the Paintings

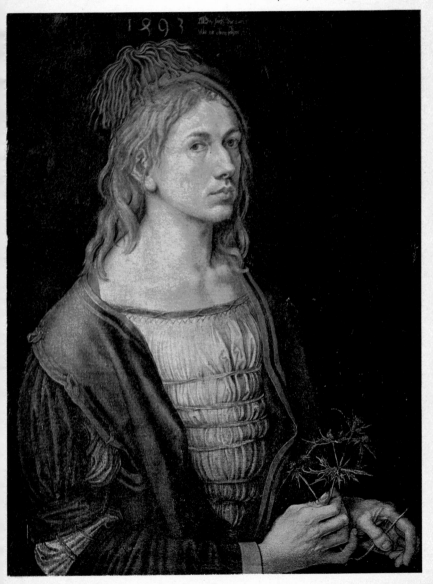

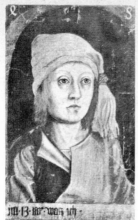

1a

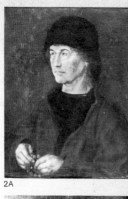

2A

2B

4

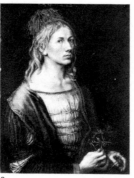

3

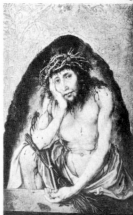

5

In some instances a letter
follows the numbering:
a/b = a copy of an original
work which has been lost.
A/B is used when the work is
part of the whole, e.g. a wing
of a triptych.
d = drawing, watercolour
All measurements are in
centimetres.

1a Self-Portrait as boy
Oil on paper/26.1 × 17.2/
1484(?)
Probably a copy of a lost
original.
Formerly Stettin,
Sammlungen des
pommerschen
Geschichtsvereins

2A Portrait of Dürer's father
with rosary
2B Reverse: Arms of the
Dürer and Holper families
Oil on panel/47 × 39/1490
Florence, Uffizi

3 Self-Portrait with Eryngium
(sea holly)
Oil on parchment mounted
on canvas/56.5 × 44.5/1493
Paris, Louvre

4d Jesus as a boy with the
globe
Miniature: tempera on
parchment/11.8 × 9.3/1493
Vienna, Graphische
Sammlung Albertina

5 Christ suffering
Oil on pine panel/30 × 19/
c.1493
Karlsruhe, Staatliche
Kunsthalle

6d St John's Cemetery near
Nuremberg
Watercolour and gouache on
paper/29.0 × 42.3/1494
Formerly Bremen, Kunsthalle
Bremen

7d The wire-drawing mill
Watercolour and gouache on
paper/28.6 × 42.6/1494
Berlin, Staatliche Museen
Preussischer Kulturbesitz,
Kupferstichkabinett

8d Three lime trees
Watercolour and gouache on
paper/37.2 × 24.6/1494
Formerly Bremen, Kunsthalle
Bremen

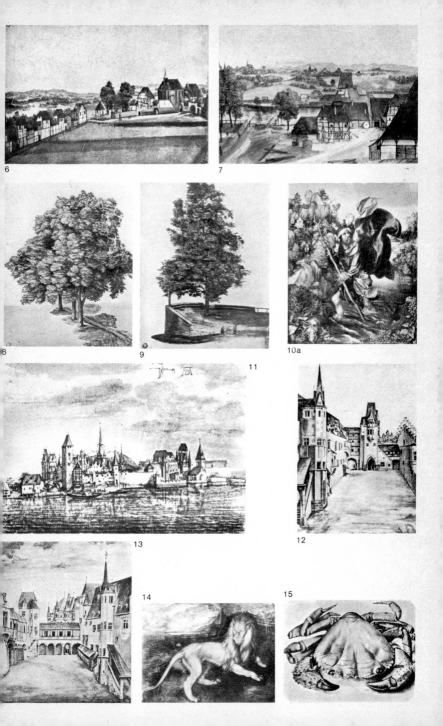

6

7

8

9

10a

11

13

12

14

15

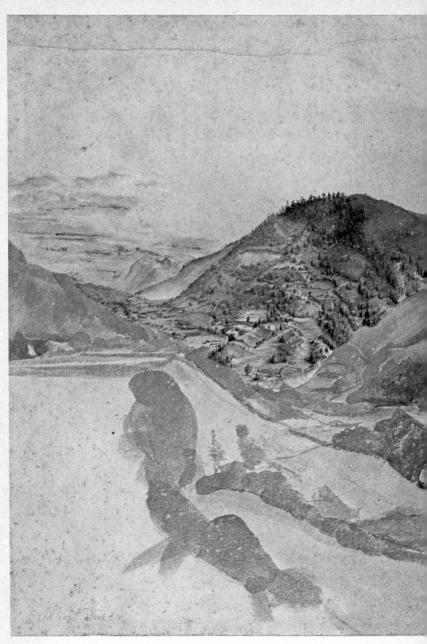

View from Arco (detail from No. 24d)
*The view of the outcrop and castle was
carefully executed by Dürer on his return
journey from Venice to Nuremberg in
late spring 1495.*

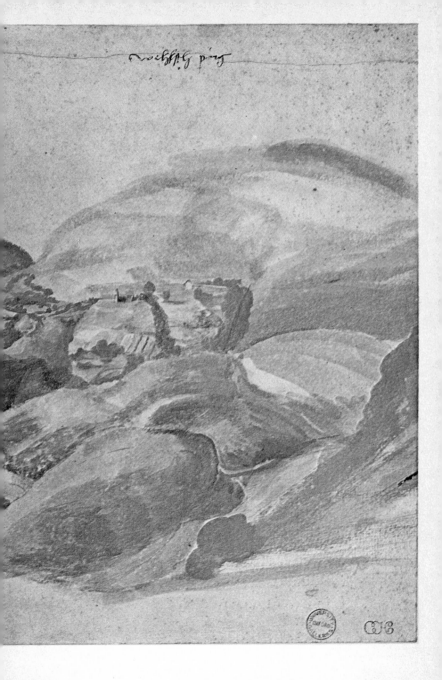

9d Lime tree on the bastion
Watercolour and gouache on parchment/34.4 × 26.7/1494
Rotterdam, Museum Boymans-van Beuningen

10a St Christopher
Oil on panel/46 × 36/
Copy (?) after Albrecht Dürer
Formerly Dessau, Staatliche Galerie

11d Innsbruck from the north
Watercolour on paper/
12.7 × 18.7/1494
Vienna, Graphische Sammlung Albertina

12d Courtyard of Innsbruck Castle
Watercolour on paper/
36.8 × 27/1494
Vienna, Graphische Sammlung Albertina

13d Courtyard of Innsbruck Castle (with clouds)
Watercolour on paper/
33.5 × 26.7/1494
Vienna, Graphische Sammlung Albertina

14d Lion
Gouache on parchment, heightened with gold/
12.6 × 17.2/1494–5
Hamburg, Hamburger Kunsthalle

15d Crab (Eriphia spinifrons)
Watercolour and white bodycolour on paper/
26.3 × 35.5/1494–5
Rotterdam, Museum Boymans-van Beuningen

16d Lobster
Pen on paper with brown and black washes/24.7 × 42.9/
1494–5
Berlin, Staatliche Museen Preussischer Kulturbesitz, Kupferstichkabinett

17d Oriental archer on horse
Pen on paper with light watercolour washes/
25.0 × 26.5/1494–5
Milan, Biblioteca Ambrosiana

18d Trento from the north
Watercolour and gouache on paper/23.8 × 35.6/1495
Formerly Bremen, Kunsthalle Bremen

16

17

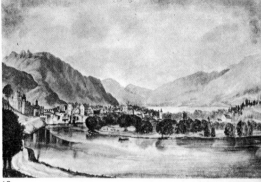

18

19

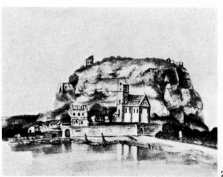

20

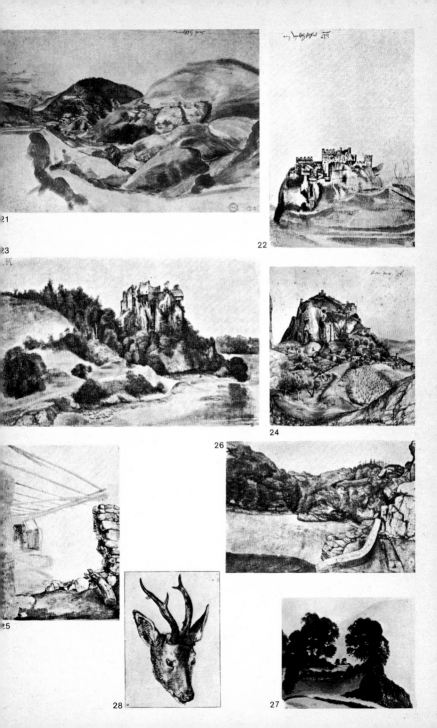

21

22

23

24

25

26

27

28

19d Trento Castle
Watercolour on paper/
19.8 × 25.7/1495
London, British Museum

20d 'Trintperg' (Dosso di Trento)
Watercolour and gouache on paper/17 × 21.2/1495
West Germany

21d 'Wehlsch Pirg' (Val di Cembra)
Watercolour on paper/
21 × 31.2/1495
Oxford, Ashmolean Museum

22d Italian Castle (Segonzano Castle?)
Watercolour and gouache on paper/19.1 × 13.9/1495
Berlin, Staatliche Museen Preussischer Kulturbesitz, Kupferstichkabinett

23d Hill Fortress by the water's edge (Segonzano Castle?)
Watercolour and gouache on paper/15.3 × 24.9/1495
Formerly Bremen, Kunsthalle Bremen

24d Arco
Watercolour and gouache on paper/22.1 × 22.1/1495
Paris, Louvre

25d Ruined mountain hut
Watercolour over outline drawing in silverpoint /
37.2 × 26.6/1495
Milan, Biblioteca Ambrosiana

26d Alpine pass
Watercolour on paper/
20.5 × 29.5/1495
El Escorial, Biblioteca del Monasterio de San Lorenza el Real

27d Group of trees with mountain path
Watercolour on paper/
14.1 × 14.8/1495
Berlin, Staatliche Museen Preussischer Kulturbesitz, Kupferstichkabinett

'Wehlsch Pirg' (No. 21d)
This watercolour shows part of the Val di Cembra lying to the east of Trento. It was probably painted on his return from Venice in spring 1495.

31

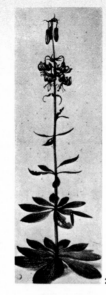

29

30

33

34

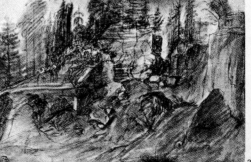

35

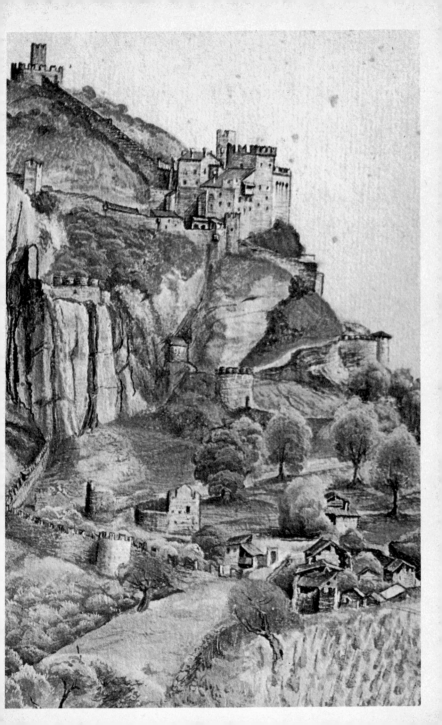

28d Head of a roebuck
Watercolour on paper/
22.8 × 16.6/1495(?)
Bayonne, Musée Bonnat

**THE ORIGIN OF THE
FOLLOWING FOUR
PLANT STUDIES (ON
PAPER) ATTRIBUTED TO
ALBRECHT DÜRER ARE
DISPUTED AND THEIR
DATES ARE UNCERTAIN.**

29d Martagon lily
Watercolour and gouache on
paper/54 × 18/1495(?)
Bremen, Kunsthalle Bremen

30d Iris
Watercolour and gouache on
paper/77 × 31/1495(?)
Bremen, Kunsthalle Bremen

31d Peony
Watercolour and gouache on
paper/37.6 × 30.8/1495(?)
Formerly Bremen, Kunsthalle
Bremen

*32d Common alkanet
(Anchusa officinalis)*
Watercolour and gouache on
paper/26.2 × 20.5/1495(?)
Formerly Bremen, Kunsthalle
Bremen

33d Quarry
Watercolour on paper/
29.2 × 22.4/1495–6
Formerly Bremen, Kunsthalle
Bremen

34d Quarry
Watercolour and gouache on
paper/22.5 × 28.7/1495–6
London, British Museum

35d Quarry
Pen drawing with
watercolour washes/
19.8 × 30.6/1495–6
Formerly Bremen, Kunsthalle
Bremen

Pine Tree (No. 39d)
*This study, portraying only the
tree itself with no indication of
its setting, was probably
painted near Nuremberg on
Dürer's return from Venice.*

36

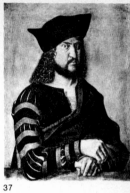

37

38A

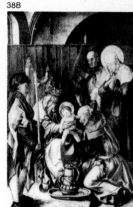

38B

38C

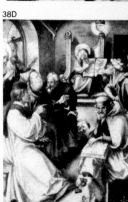

38D

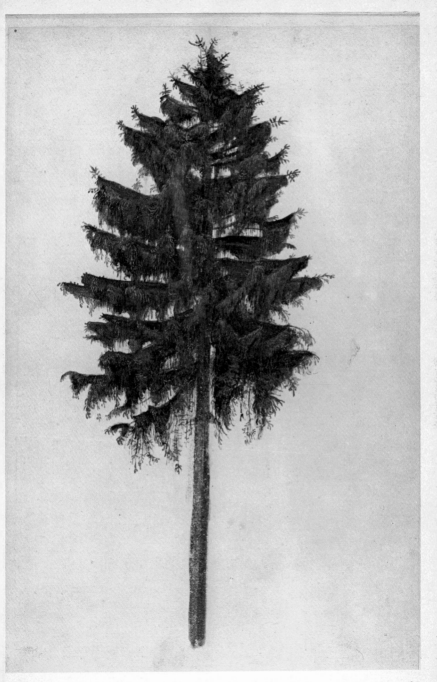

36d The Holy Family
Gouache heightened with
gold on parchment/16 × 11.2/
1495–7
Leipzig, Museum der
bildenden Künste

**37 Frederick the Wise, Elector
of Saxony**
Tempera on linen/76 × 57/
1496
Berlin, Staatliche Museen
Preussischer Kulturbesitz,
Kupferstichkabinett

**38 ALTAR OF THE SEVEN
SORROWS OF THE
VIRGIN**
38A The Mother of Sorrow/
109.2 × 43.3/
Munich, Alte Pinakothek
38B Christ's Circumcision
38C The Flight into Egypt
38D Christ among the Doctors
38E Carrying the Cross
38F The Crucifixion
38G Christ on the Cross
**38H Lamentation over the
Dead Christ**
Oil on pine panel/all about
63 × 45/c.1496
Dresden, Staatliche
Gemäldegalerie, Alte Meister

39d Pine Tree
Watercolour and gouache on
paper/29.5 × 19.6/c.1496–7
London, British Museum

**40d View of Nuremberg from
the west**
Watercolour and gouache on
paper/16.3 × 34.4/1496–7
Formerly Bremen, Kunsthalle
Bremen

41d Quarry
Watercolour on paper/
23.3 × 19.7/1496–8
Milan, Biblioteca
Ambrosiana

42d Quarry
Watercolour on paper/
21.4 × 16.8/1496–8
Berlin, Staatliche Museen
Preussischer Kulturbesitz,
Kupferstichkabinett

**43 Portrait of Albrecht Dürer,
the elder**
Oil on lime panel/51 × 39.7/
1497
London, National Gallery

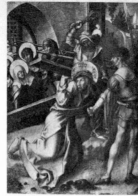

38E

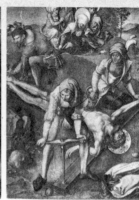

38F

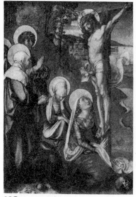

38G

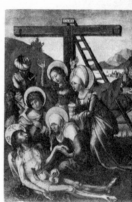

38H

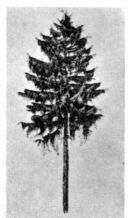

39

41

40

42

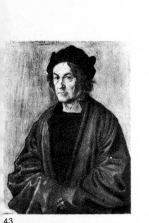

43

44

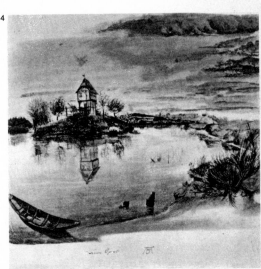

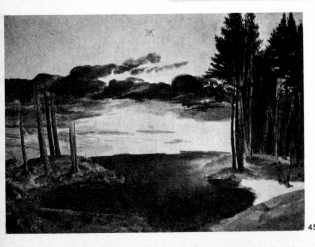

45

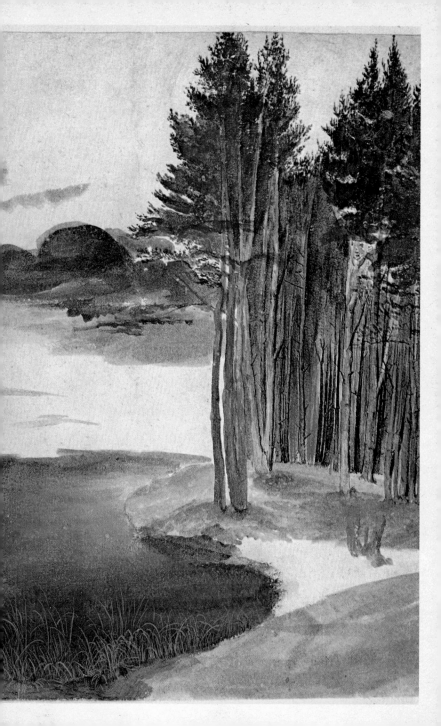

44d House on an island in a pond
Watercolour and gouache/
21.3 × 22.2/1497–8
London, British Museum

45d Pond in the woods
Watercolour and gouache on
paper/26.2 × 37.4/1497–8
London, British Museum

46A St Anthony
46B Madonna and sleeping child
46C St Sebastian
Tempera on linen/Centre
117 × 96.5; Wings/each
114 × 45/c.1497–8
Dresden, Staatliche
Gemäldegalerie, Alte Meister

47 The Virgin before the archway
Oil on panel/47.8 × 36/
c.1497–8
Mamiano – Parma, Magnani
Collection

48 Self-Portrait with landscape
Oil on panel/52 × 41/1498
Madrid, Prado

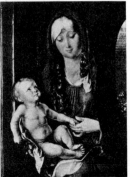

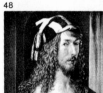

**Pond in the woods (No. 45d)
(pp. 24–5)**
*This landscape is typical of the
countryside around
Nuremberg. The semi-finished
appearance of the picture
makes it seem almost modern.*

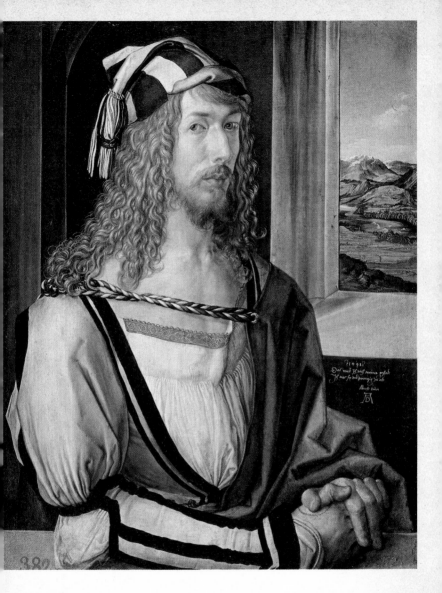

***Self-Portrait with landscape
(No. 48)***
*The composition is the result
of intense interest in the
principles of Italian
Renaissance art. The clothes
are elegant and proudly worn
and indicate that the painter
has reached a new level of
assurance and confidence.*

49d Soldier on horseback with lance
Pen drawing on paper with watercolour washes/41 × 32.4/ 1498(?)
Vienna, Graphische Sammlung Albertina

50A Virgin with child at window (Madonna of the Haller family)
50B Reverse: Lot and his family fleeing from Sodom
Oil on panel/50.2 × 39.7/ *c*.1498
Washington, National Gallery of Art (Kress Collection)

51d The barren path at the Haller gateway
Pen drawing on paper with light watercolour washes/ 16 × 32.3/1498–9
Vienna, Graphische Sammlung Albertina

52d Jousting helmet: three views
Watercolour and gouache on paper/42.2 × 26.8/*c*.1498–1500
Paris, Louvre

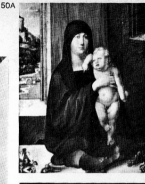

50A

49

50B

51

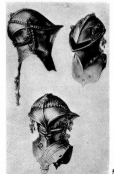

52

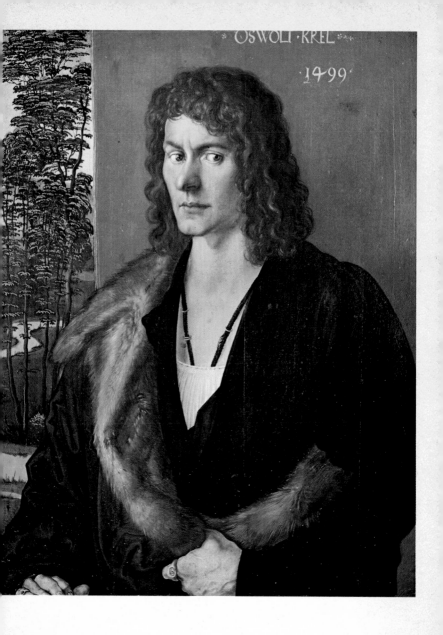

**Portrait of Oswolt Krel 1499
(No. 53A)**
*The extraordinary tension in
this portrait is increased still
further by the intense red
of the background.*

53A Portrait of Oswolt Krel
Oil on lime panel/49.6 × 39/
***53B Wild men with coats of
arms of Oswolt Krel and
53C the arms of his wife
Agathe (née von Essendorf)***
Originally shutters for the
portrait/49.3 × 15.9 and
49.7 × 15.7/1499
Munich, Alte Pinakothek

***54A Pendant pictures of Hans
54B Felicitas Tucher***
Oil on panel/each 28 × 24/
1499
Formerly Weimar,
Schlossmuseum (stolen in
1945; now in New York)

55 Portrait of Elsbeth Tucher
Oil on lime panel/29 × 23.3/
1499
Kassel, Staatliche
Kunstsammlungen

***56 Portrait of a young man
(Hans Dürer?)***
Oil on lime panel/28 × 21;
extended on right and left-
hand sides by approx 2.3 cm/
1500
Munich, Alte Pinakothek

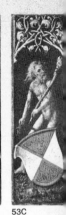

53A

53B

53C

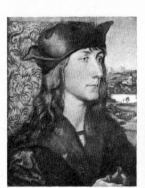

54A

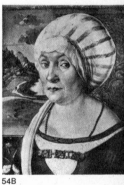

54B

55

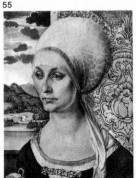

56

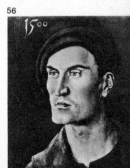

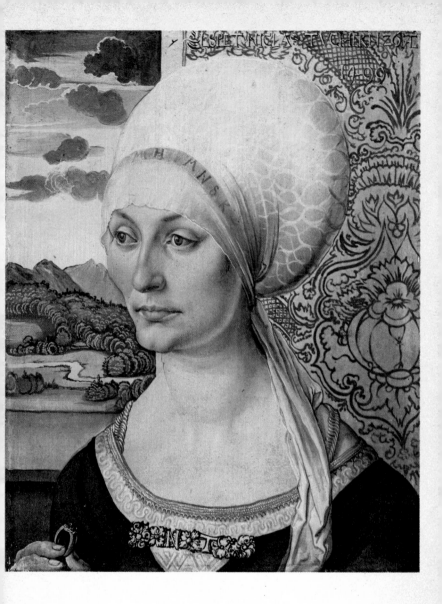

Portrait of Elsbeth Tucher
(No. 55)
*This painting combines a
close-up of the sitter's face
with a view of the landscape
which fades into the distance.
The ring in the woman's hand
and the letters 'NT' refer to
her husband Niclas Tucher
whose portrait has been lost.*

57 Hercules and the Stymphalian birds
Tempera on linen/87 × 110/ 1500
Nuremberg, Germanisches Nationalmuseum (on loan from the Bayerische Staatsgemäldesammlungen)

58 Lamentation over the dead Christ for Albrecht Glimm
Oil on spruce panel/ 151 × 121/1500
Munich, Alte Pinakothek

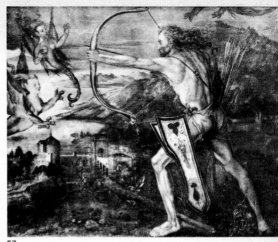

57

58

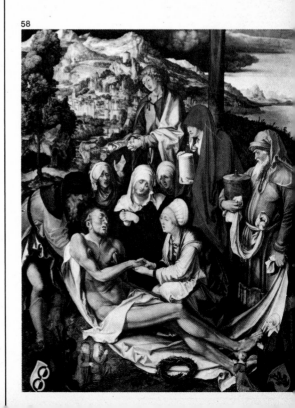

Head of the dead Christ (detail from No. 58)
The theme of the lament for Christ taken down from the cross and laid out on a pall was a peculiarity of German art. It was used by Dürer several times around 1500. It appears to have been regarded as a particularly suitable theme for memorials to the dead in Nuremberg.

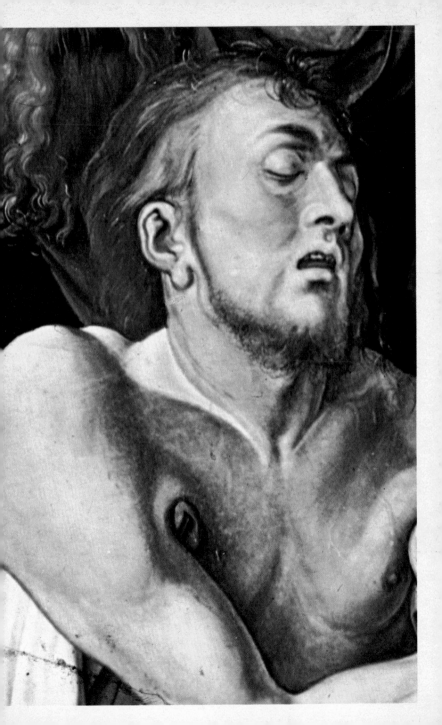

59 Self-Portrait in fur mantel
Oil on lime panel/67 × 49/
1500
Munich, Alte Pinakothek

60d Nuremberg woman in house dress
Pen drawing with light
watercolour washes on paper/
32 × 21.2/1500
Vienna, Graphische
Sammlung Albertina

61d Nuremberg woman in house dress
Pen drawing with light
watercolour washes/28.4 × 13/
1500
Milan, Biblioteca
Ambrosiana

62d Nuremberg woman dressed for dancing
Pen drawing on paper with
light watercolour washes/
32.5 × 21.8/1500
Vienna, Graphische
Sammlung Albertina

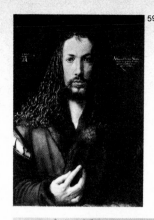

59

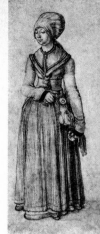

61

60

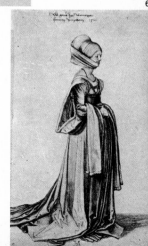

6

Nicodemus (detail from No. 58)
The mourning of Christ anticipates the subsequent burial. That is why Nicodemus appears among the mourners. St John the Evangelist reported that he had contributed one hundred pounds to obtain a mixture of myrrh and aloes for embalming the body.

34

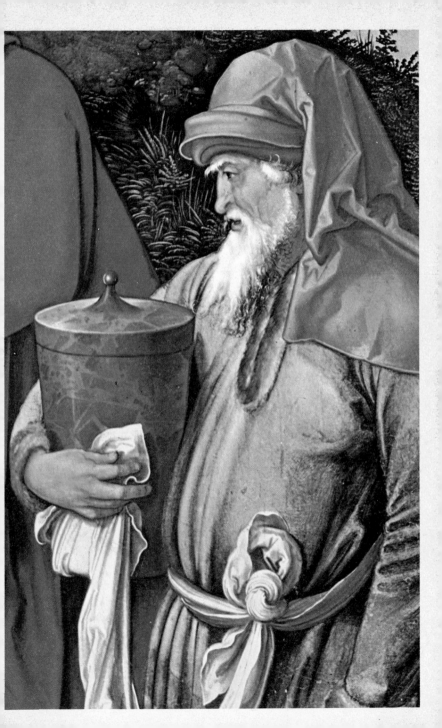

63d Nuremberg woman dressed for church
Pen drawing on paper with light watercolour washes/
32 × 20.5/1500
Vienna, Graphische Sammlung Albertina

64d Nuremberg woman dressed for church
Brush drawing on paper with light watercolour washes/
31.7 × 17.2/1500
London, British Museum

65d Nuremberg girl dressed for dancing
Pen drawing on paper with light watercolour washes/
32.4 × 21.1/1501
Basel, Öffentliche Kunstsammlungen, Kupferstichkabinett

66 Portrait of a man with arrows
Oil on panel/52 × 40/c.1500
Bergamo, Accademia Carrara, Lochis Collection

67 Lamentation over the dead Christ for the Holzschuher family
Albrecht Dürer's studio
Oil on pine panel/
150 × 120/after 1500
Nuremberg, Germanisches Nationalmuseum (on loan from the Wittelsbacher Ausgleichsfond)

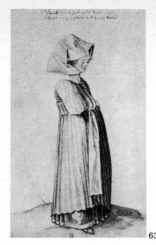

63

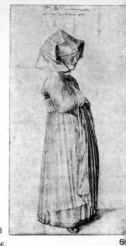

65

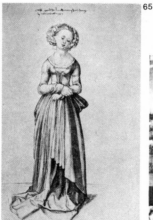

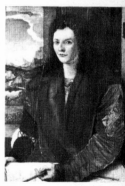

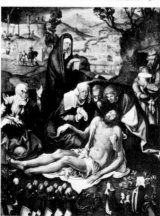

67

St John the Evangelist (detail from No. 58)
John is the only apostle to stand beneath the cross. Dürer depicts him as a youth in deep sorrow: his hands are clenched in pain and prayer.

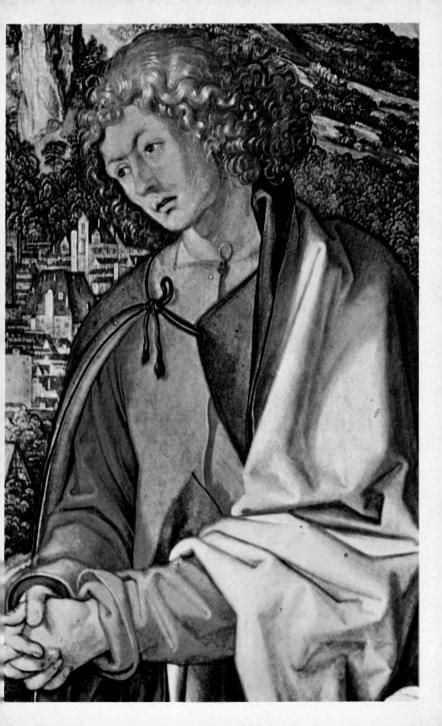

TWO PANELS FROM A SMALL ALTARPIECE
Oil on panel/each 58 × 21/
c.1500–4
68A St Onuphrius
Bremen, Kunsthalle Bremen
68B St John
Formerly Bremen, Kunsthalle Bremen

69 Salvator mundi
Unfinished
Oil on panel/58.1 × 47/
c.1500–4
New York, Metropolitan Museum of Art (Friedsam Collection)

70d Reclining nymph
Pen drawing on green grounded paper heightened with white/17 × 22/1501
Vienna, Graphische Sammlung Albertina

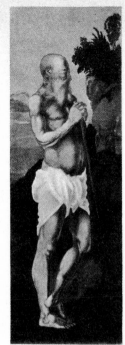
68A

68B

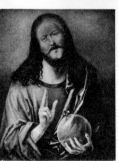
69

Landscape from the votive picture for Albrecht Glimm (detail from No. 58)
In this landscape the medieval artist's perception of the City of Jerusalem combines with Dürer's actual experiences on his Alpine travels during 1494–5 to produce a landscape with considerable depth.

70

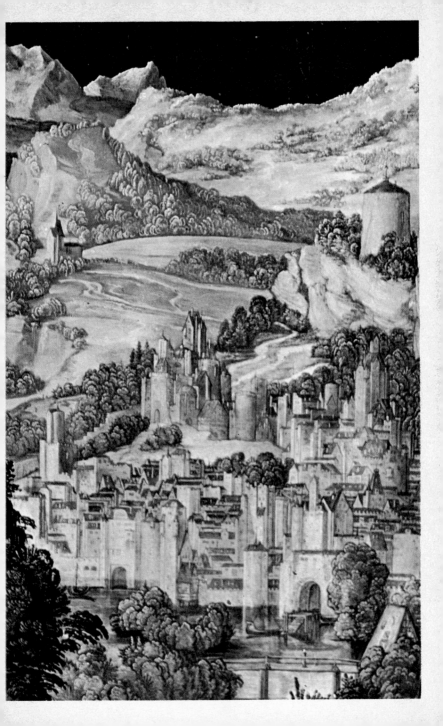

71d Elk
Watercolour on paper/
21 × 26/*c.*1501
London, British Museum

72d The young hare
Watercolour and gouache on
paper/25.1 × 22.6/1502
Vienna, Graphische
Sammlung Albertina

*PAUMGÄRTNER FAMILY
ALTARPIECE*
Oil on lime panel
*73A St George (Stephen
Paumgärtner?)*
73B The Nativity
155 × 126
*73A1 Reverse: The
Annunciation*
*73C St Eustace (Lukas
Paumgärtner?)*
/each 157 × 61/*c.*1502
Munich, Alte Pinakothek

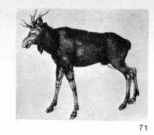
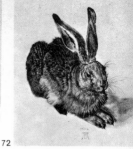
71

72

73B

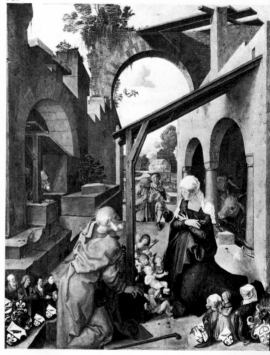

73A

73C

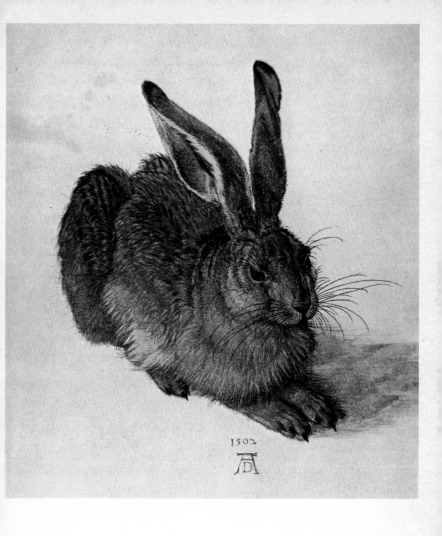

The young hare (No. 72d)
The famous watercolour, with very close attention to detail, manages to capture all the characteristics which one associates with a hare.

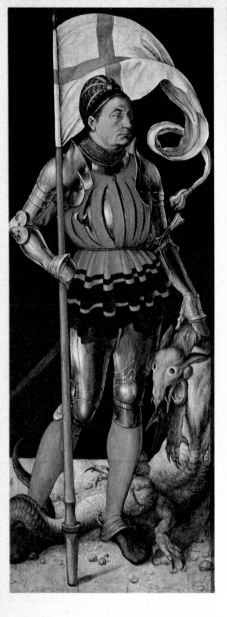

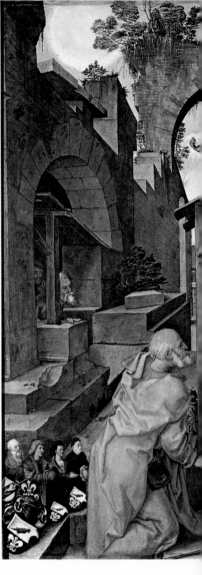

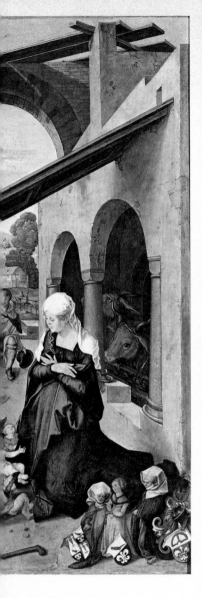
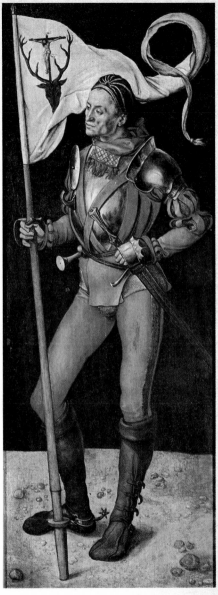

The Paumgärtner Family altarpiece (No. 73 A–C)
*In both subject matter and arrangement this is still in the
tradition of medieval altar paintings. Nevertheless, the
way Dürer has handled the individual characters and the
overall composition indicate full awareness of the new
Renaissance art.*

74d Parrot
Pen drawing with
watercolour washes/
19.3 × 21.3/before 1503
Milan, Biblioteca
Ambrosiana

75 Virgin and child
Oil on panel/24 × 18/1503
Vienna, Kunsthistorisches
Museum

76d The Virgin with animals
Pen and watercolour on
paper/32.1 × 24.3/1503
Vienna, Graphische
Sammlung Albertina

77d The large piece of turf
Watercolour and gouache on
paper/41 × 31.5/1503
Vienna, Graphische
Sammlung Albertina

**78d Portrait of a young
woman (Agnes Dürer?)**
Watercolour on linen/
25.6 × 21.7/1503
Paris, Louvre, Cabinet des
Dessins

79d Heron
Watercolour on parchment/
26.7 × 34.7/s./c.1503
Berlin, Staatliche Museen
Preussischer Kulturbesitz,
Kupferstichkabinett

80d Muzzle of an ox
Watercolour and gouache on
paper/19.7 × 15.8/c.1503
London, British Museum
Similar to 81d

81d Muzzle of an ox
Watercolour and gouache on
paper/19.9 × 15.8/c.1503
London, British Museum
Similar to 80d

**Lukas Paumgärtner as St
Eustace (detail from No. 73C)**
*The distinctive standing figures
on the wings of the
Paumgärtner altar suggest
that they are probably
portraits of members of the
family. Portraying close
relatives of the founder on
altar pictures was criticized by
the satirists of the day.*

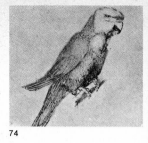

74

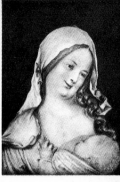

75

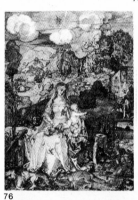

76

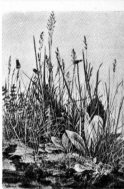

77

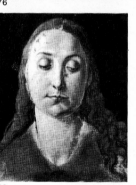

78

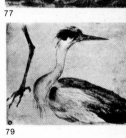

79

81

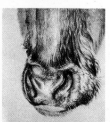

80

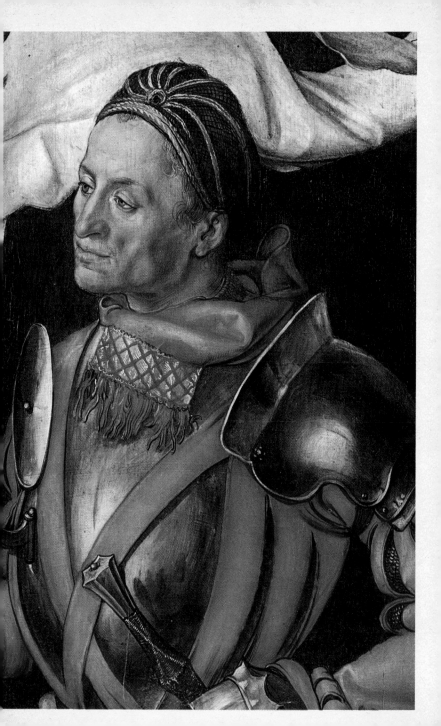

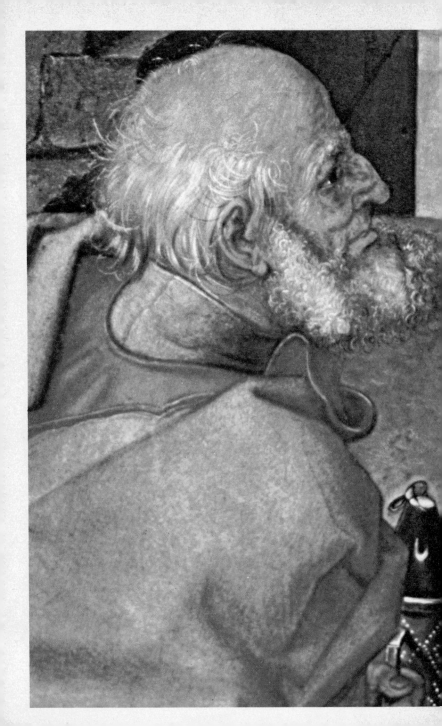

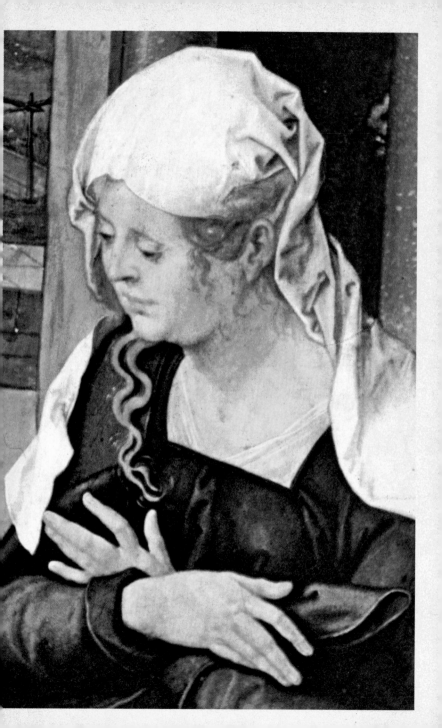

THE ATTRIBUTION OF THE FOLLOWING PLANT DRAWINGS TO DÜRER IS DISPUTED BY SOME AUTHORITIES.

82d Greater Celandine (Chelidonium majus)
Watercolour and gouache on parchment/28.8 × 15/c.1503
Vienna, Graphische Sammlung Albertina

83d Columbine (Aquilegia vulgaris)
Watercolour and gouache on parchment/36.5 × 28.6/c.1503
Vienna, Graphische Sammlung Albertina

84d Wild Lettuce (Lactuca scariola)
Watercolour and gouache on paper/35.1 × 11.6/c.1503
Bayonne, Musée Bonnat

82

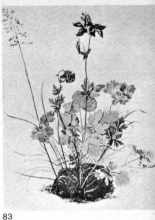

83

The Nativity (detail from No. 73B) (p. 46)
Joseph in profile is noticeably placed at a lower level than Mary and is glancing up at her. The lamp in his hand signifies not only that the miraculous events took place in the hours of darkness but that there is now a 'new light' in the world.

The Nativity (detail from No. 73B) (p. 47)
Mary in the traditional blue garment has loosened her head-dress and kneels in wonder before the child who has so miraculously come into the world.

The Nativity (detail from No. 73B) (p. 49)
Between Mary and Joseph the eye is drawn through the ruined perspective into the distant landscape which is interrupted by the figures of an old and a young shepherd who have come in haste to see what the angel has proclaimed to them in the fields.

85

84

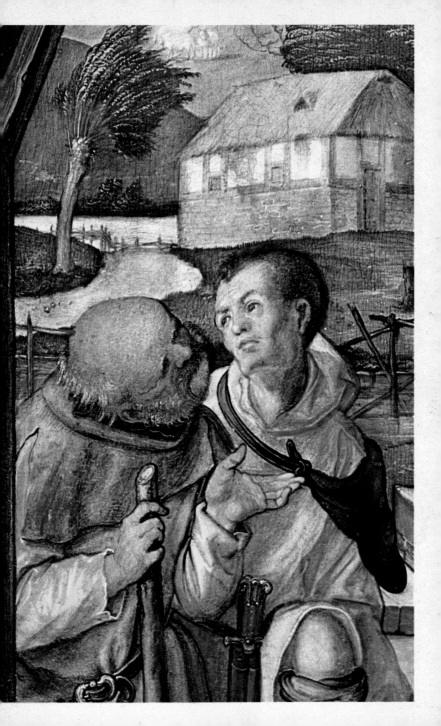

85d Wild pansy (Viola tricolor L.), Brunelle (Brunella vulgaris L.), Scarlet pimpernel (Anagallis arvensis L.)
Watercolour and gouache on parchment/29.2 × 15/c.1503
Vienna, Graphische Sammlung Albertina

86d The small piece of turf
Gouache on parchment/ 11.7 × 15/c.1503
Vienna, Graphische Sammlung Albertina

87d Youth's head inclined to the right
Watercolour on linen/ 22.6 × 19.3/c.1503
Paris, Bibliothèque Nationale

88d Youth's head inclined to the left
Watercolour on linen/ 23.3 × 18.1/c.1503
Paris, Bibliothèque Nationale

89Ad Book plate for Willibald Pirckheimer
from Theocritus: *Idyllia*. Venice 1495–6
Gouache heightened with white and gold/30 × 21/before 1504
Private collection

87

8

86

8

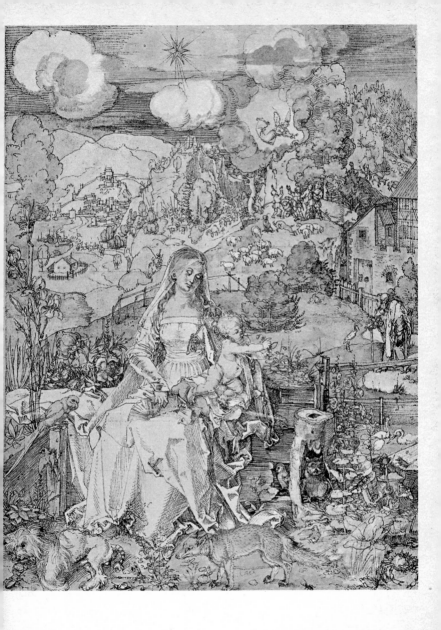

The Virgin with animals (No. 76d)
*Dürer has managed to retain some of the
symbolism of the Middle Ages in his
careful drawings of natural objects such
as animals and plants. This is clear when
the studies are presented in the wider
context of Christianity.*

89B

89Bd Book plate for Willibald Pirckheimer

from Aristotle: *Opera.* Venice 1497
Gouache heightened with white and gold/9 × 19.8/before 1504
Rotterdam, Museum Boymans-van Beuningen

89C

89Cd Book plate for Willibald Pirckheimer

from Simplicius: *Decem Categorias Aristoteles Grece.* Venice 1499
Gouache heightened with gold/7.5 × 19.7/before 1504
Copenhagen, Kongelige Bibliotek

89Dd Book plate for Willibald Pirckheimer

from Suidas: *Lexicon Graecum.* Milan 1499
Gouache heightened with gold/18.5 × 22.2/before 1504
London, British Museum

89D

89Ed Book plate for Willibald Pirckheimer

from Appianus: *Historia Romana de Bellis Civilibus.* Venice 1477
Gouache heightened with gold/6.9 × 9.6/after 1504
Rotterdam, Museum Boymans-van Beuningen

89Fd Book plate for Willibald Pirckheimer

from Josephus Flavius: *Opera latina.* Verona 1480
Gouache heightened with gold/7.2 × 12.4/after 1504
Berlin, Hans Fürstenberg Collection

89E

89F

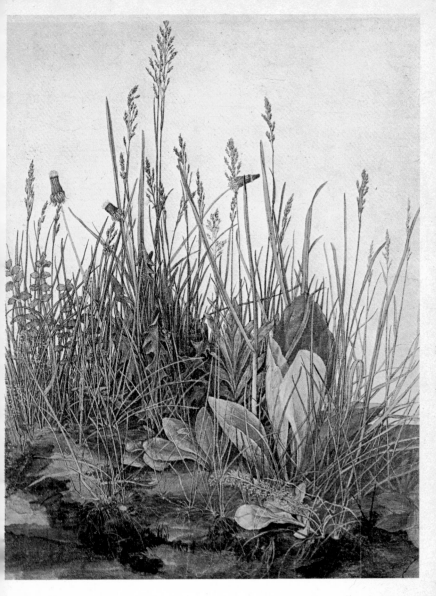

The large piece of turf (No. 77d)
This chance combination of yarrow, dandelion, meadow grass and plantain happened to be growing together and were lifted from the side of a damp meadow. Under Dürer's brush they appear as a carefully composed work of art in which each small detail contributes to the overall picture.

89Gd Book plate for Willibald Pirckheimer
from Planudes: *Anthologia Epigrammatum Graecorum*. Florence 1494
Gouache heightened with gold/5.3 × 5.6/after 1504
Rotterdam, Museum Boymans-van Beuningen

89Hd Book plate for Willibald Pirckheimer
from Aristotle: *Opera*. Venice 1497
Gouache heightened with white and gold/7 × 19/after 1504
Hanover, Niedersächsische Landesbibliothek

89Id Book plate for Willibald Pirckheimer
from Urbanus Bolzanius Bellunensis: *Institutiones Graecae Grammaticae*. Venice 1497
Gouache heightened with white and gold/4 × 4.4/after 1504
Rotterdam, Museum Boymans-van Beuningen

89Jd Book plate for Willibald Pirckheimer
from Aristophanes: *Comoediae novem*. Venice 1498
Gouache heightened with white and gold/4.6 × 13.4/after 1504
Rotterdam, Museum Boymans-van Beuningen

89Kd Book plate for Willibald Pirckheimer
from *Ethymologium magnum Graecum*. Venice 1499
Gouache heightened with gold/9.3 × 23.8/after 1504
Rotterdam, Museum Boymans-van Beuningen

89G

89H

89J

89I

89K

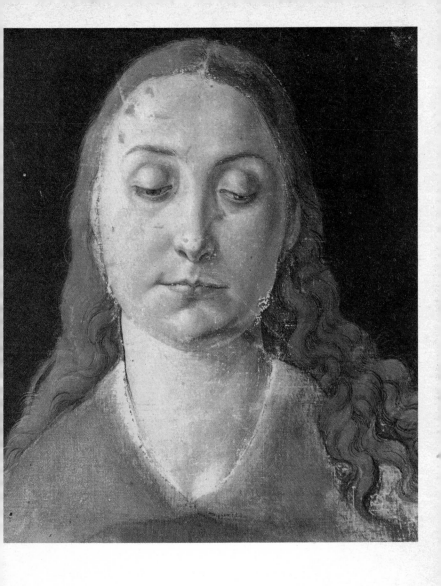

**Portrait of a young woman
(No. 78d)**
The date of this picture
(1503) has only recently been
established. It tends to confirm
the traditional view that the
sitter is Dürer's wife Agnes.

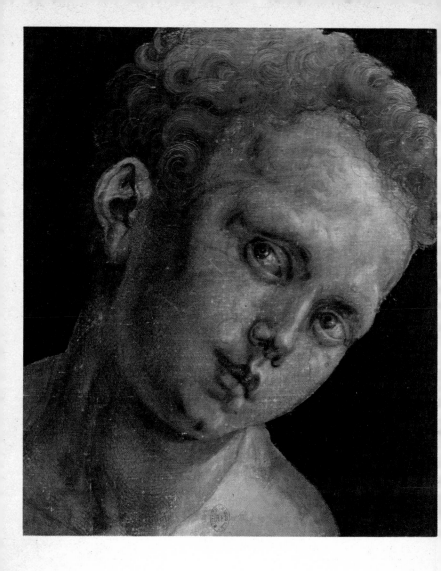

Youth's head inclined to the right (*No. 87d*)
The reason for this study is not known. Unlike other similar works, this watercolour on linen was not used as a preparatory work for a subsequent painting.

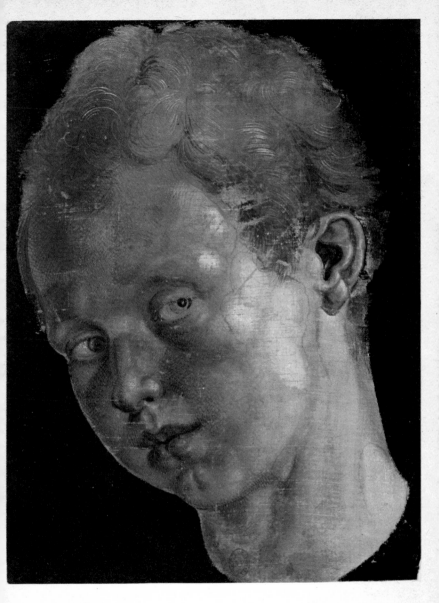

Youth's head inclined to the left (No. 88d)
Dürer was fascinated by the use of watercolour on linen and frequently used this medium, particularly during his early years, although the technique was seldom used by other German artists.

90 Adoration of the Magi
Oil on panel/100 × 114/1504
Florence, Uffizi

ALTARPIECE
Oil on lime panel/c.1504
91A Patient Job
96 × 51
Frankfurt, Städelsches
Kunstinstitut
91B Piper and drummer
94 × 51
Cologne, Wallraf-Richartz-
Museum
91C St Joseph and St Joachim
96 × 54
91D St Simon and St Lazarus
97 × 55
Munich, Alte Pinakothek

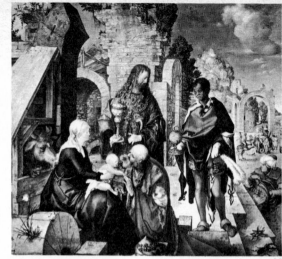

90

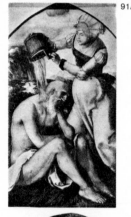

91A

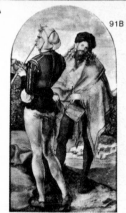

91B

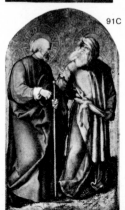

91C

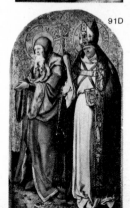

91D

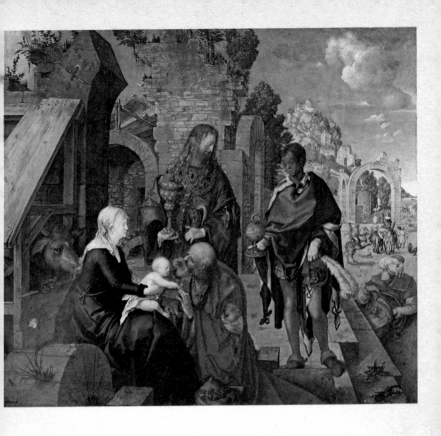

**The Adoration of the Magi
(No. 90)**
*The altar picture in its present
form has no wings and may
possibly have been intended as
an independent painting in line
with Italian trends. The main
group of figures in the
foreground stand out from
those in the background and
complement each other.*

92 Portrait of Venetian lady
Oil on elm panel/32.5 × 24.5/
1505
Vienna, Kunsthistorisches
Museum

**93 The Feast of the Rose-
garlands**
Oil on poplar panel/
162 × 194.5/1506
Prague, Nationalgalerie

94 Christ among the doctors
Oil on poplar panel/65 × 80/
1506
Lugano-Castagnola, Thyssen-
Bornemisza Collection

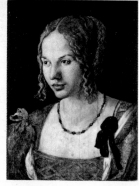

92

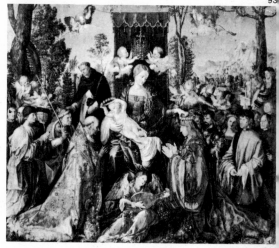

93

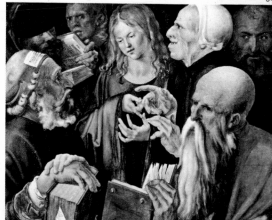

94

*The Adoration of the Magi
(detail from No. 90)*
*The group of characters form
a close-knit triangle. The
strong horizontal and vertical
lines of the stonework in the
background contrasts with the
figures which are slightly
inclined to the right. Because
the second king turns to look
at the black king standing
apart a feeling of movement is
created.*

95 The Virgin with the goldfinch
Oil on poplar panel/91 × 76/1506
Berlin, Staatliche Museen, Stiftung Preussischer Kulturbesitz, Gemäldegalerie

96 Portrait of Burkard von Speyer
Oil on panel/32 × 27/1506
Windsor castle, Royal Collection

97 Portrait of a young man
Oil on panel/47 × 35/1506
Genoa, Galleria di Palazzo Rosso

98 Portrait of Venetian lady
Oil on poplar panel/28.5 × 21.5/1506
Berlin, Staatliche Museen, Stiftung Preussischer Kulturbesitz, Gemäldegalerie

99d A tree
Watercolour and gouache on paper/29.6 × 21.9/c.1506
Milan, Biblioteca Ambrosiana

100d Mill in the pasture
Watercolour and gouache on paper/25.1 × 36.7/c.1506
Paris, Bibliothèque Nationale, Cabinet des Estampes

Piper and Drummer (No. 91B)
The musicians are drawn to Patient Job on the opposite wing panel (No. 91A). One can interpret their music either as mocking Job or as comforting him. In the latter case the musicians can be seen as representing Dürer's own view.

62

95

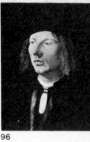

96

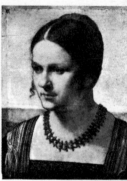

98

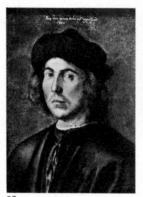

97

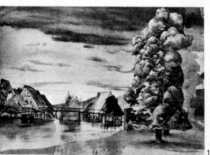

100

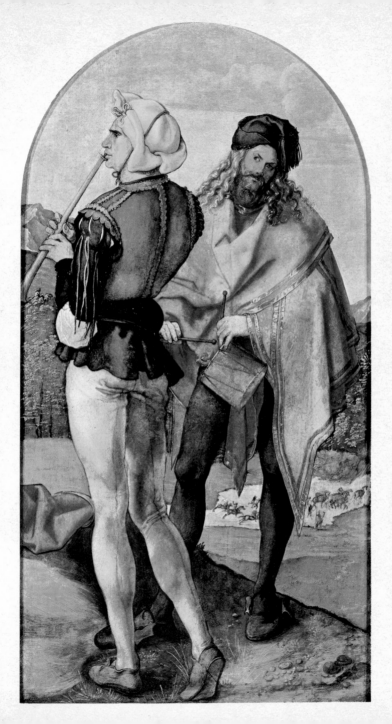

101A Adam
Oil on pine panel/209 × 81/
1507
101B Eve
Oil on pine panel/209 × 83/
1507
Madrid, Prado

102A Portrait of a young man
102B Reverse: Old woman
with purse
Oil on lime panel/35 × 29/
1507
Vienna, Kunsthistorisches
Museum

103 Portrait of girl with a red
cap
Oil on parchment mounted
on panel/30.4 × 20/1507
Berlin, Staatliche Museen
Preussischer Kulturbesitz,
Gemäldegalerie

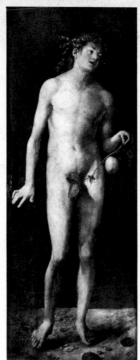

101A

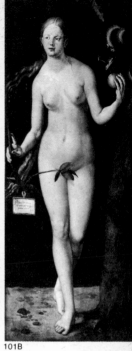

101B

102A

103

102B

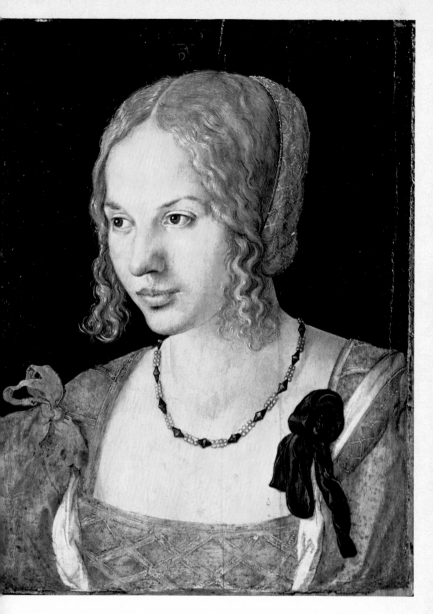

Portrait of a young Venetian lady (No. 92)
*Not quite finished, it belongs, as can be seen from
the evidence on the painting itself (top centre), to
1505 and is one of the earliest of Dürer's works
painted during his second stay in Venice. The
onlooker is concious of the lively quality of the
portrait which suggests that the painter knew the
young woman quite well.*

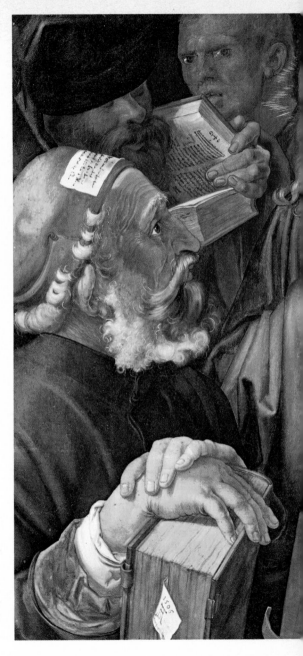

Christ among the doctors (No. 94)
Dürer himself described this as a unique picture unlike anything else he had done. It combines northern art with Venetian figures and Leonardo's intimate studies. It shows a link with the Venetian painters and particularly the later works of Giorgione.

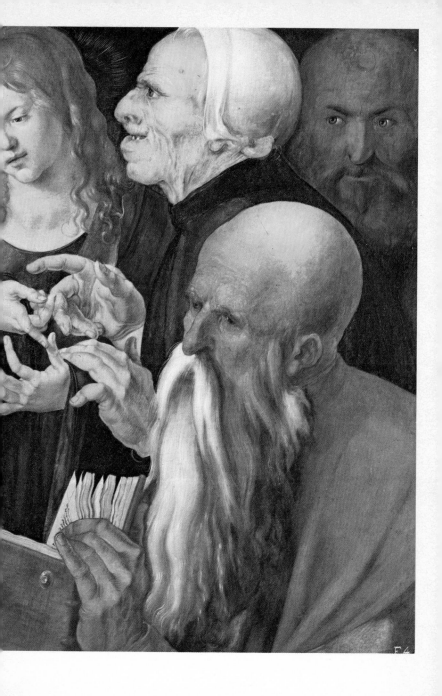

104 The Martyrdom of the Ten Thousand Christians
Oil on panel, transferred to canvas/ 99 × 87/1508
Vienna, Kunsthistorisches Museum

105 The Holy Family
Oil on panel/30.5 × 28.7/1509
Rotterdam, Museum Boymans-van Beuningen

106 The Adoration of the Trinity
Oil on panel/135 × 123.4/1511
Vienna, Kunsthistorisches Museum

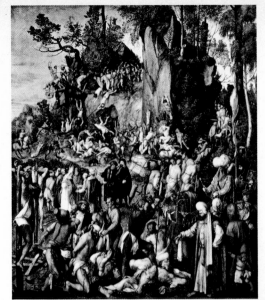

104

105

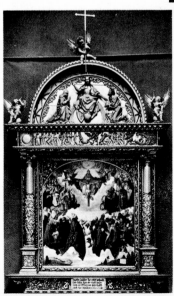

106

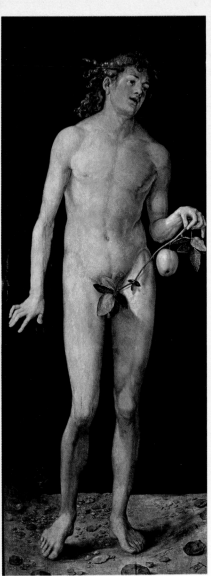
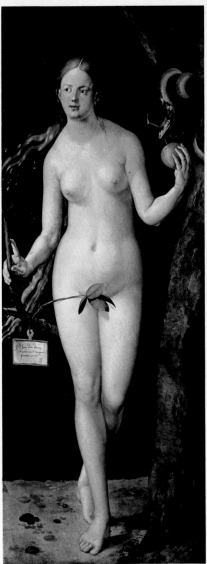

Adam and Eve (No. 101 A-B)
This theme enabled Dürer to depict the beauty of the human body. He has painted the figures against a dark background distinguishing the shades: cooler for the woman and warmer for the man.

107 Virgin and child
Oil on lime panel/49 × 37/
1512
Vienna, Kunsthistorisches
Museum

108d Dead roller (Coracias garrulus)
Watercolour and gouache on
parchment/28 × 20/1512(?)
Vienna, Graphische
Sammlung Albertina

109d Wing of roller (Coracias garrulus)
Gouache on parchment/
19.7 × 20/1512(?)
Vienna, Graphische
Sammlung Albertina

110 The Emperor Charlemagne
Oil on lime panel/188 × 88/
1513
Nuremberg, Germanisches
Nationalmuseum
Pendant to No. 111

111 The Emperor Sigismund
Oil on lime panel/188 × 88/
1513
Nuremberg, Germanisches
Nationalmuseum
Pendant to No. 110

The Martyrdom of the Ten Thousand (detail from No. 104) (p. 72)
The execution of the Christian soldiers on Mount Ararat gave Dürer the opportunity to show naked bodies in a variety of situations. The dazzling colours subdue the horrors of the ghastly scene.

The Martyrdom of the Ten Thousand (detail from No. 104) (p. 73)
According to legend it was at the behest of the Roman Emperors Hadrian and Antoninus that the oriental princes condemned the 10,000 Christian soldiers to death.

107
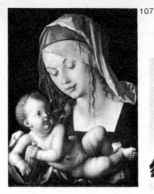

109
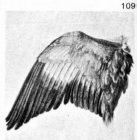

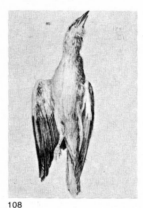

108
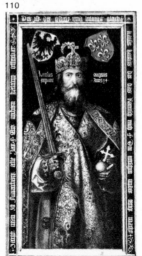

112
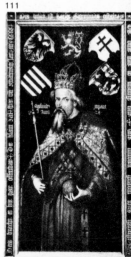

110

111

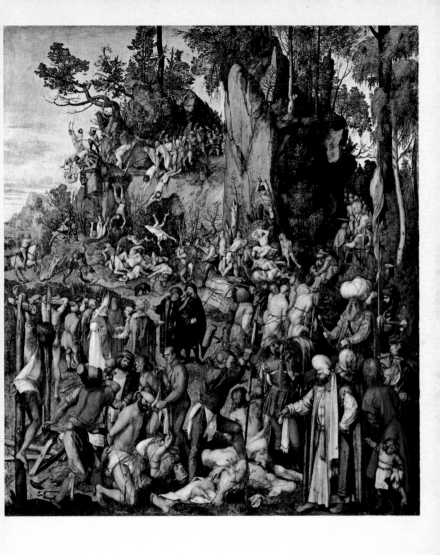

The Martyrdom of the Ten Thousand Christians (No. 104)
This work, commissioned by Frederick the Wise, represents the martyrdom of 10,000 Christians at Bithynien in 303. Dürer and a friend are included in the centre of the painting. This is one of his most developed, rich and harmonious compositions.

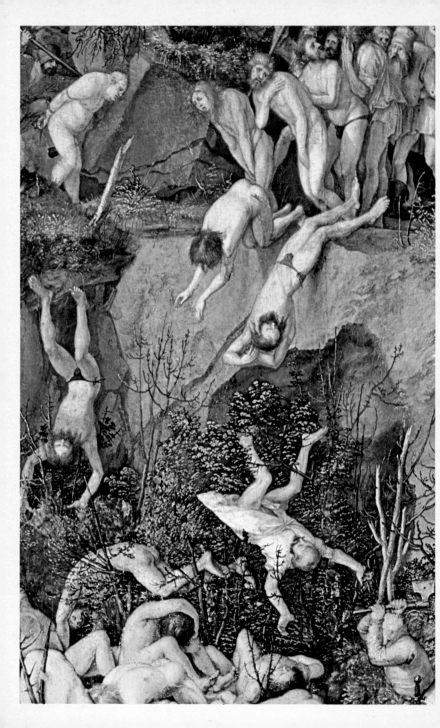

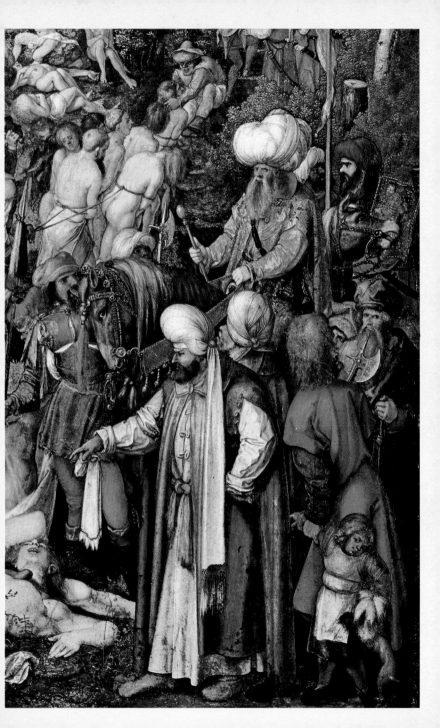

112d Duck
Watercolour and gouache on parchment/23.3 × 12.7/ 1515(?)
Lisbon, Fundaçào Gulbenkian

113 St Philip
Oil on canvas/46 × 38/1516
Florence, Uffizi
Pendant to No. 114

114 St James
Oil on canvas/46 × 38/1516
Florence, Uffizi
Pendant to No. 113

115 The Virgin with a carnation
Oil on parchment mounted on panel/ 39 × 29/1516
Munich, Alte Pinakothek

116 Virgin and child
Oil on panel/27.9 × 18.8/1516
New York, Metropolitan Museum of Art

117 Portrait of Michael Wolgemut
Oil on lime panel/29 × 27/ 1516
Nuremberg, Germanisches Nationalmuseum (on loan from the Bayerische Staatsgemäldesammlungen)

118 Portrait of a cleric
Oil on parchment mounted on panel/41.5 × 33/1516
Washington, National Gallery of Art

113

114

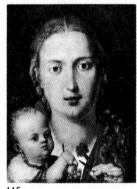
115

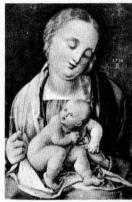
116

118
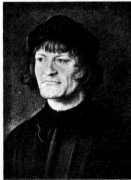

117
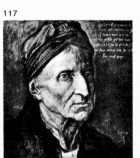

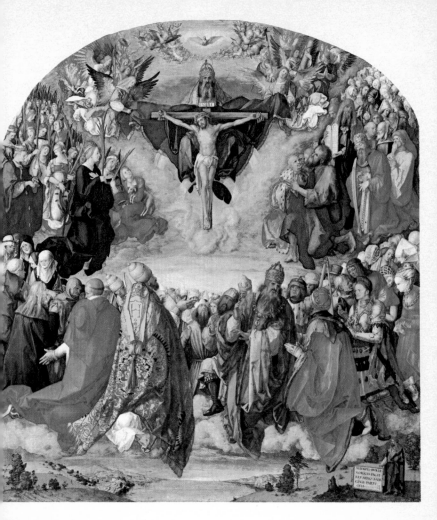

**The Adoration of the Trinity
(No. 106)**
*This painting was
commissioned by Matthäus
Landauer for the chapel which
he endowed and dedicated to
All Saints in the
Zwölfbrüderhaus. Here Dürer
applies his skills and
experience of drawing figures
to the mysteries of
the Christian faith. In a large
space full of light, multitudes
of the Church, some arguing
others triumphant, float above
the ground and pray to the
Holy Trinity.*

119 Man's head
Oil on canvas mounted on
panel/ 26 × 21/1516–20
Chicago, Art Institute

120d Kalchreuth village
Watercolour and gouache on
paper/21.6 × 31.4/c.1516–20
Formerly Bremen, Kunsthalle
Bremen

121d Kalchreuth valley
Watercolour and gouache on
paper/10.3 × 31.6/c.1516–20
Berlin, Staatliche Museen
Preussischer Kulturbesitz,
Kupferstichkabinett

122 Lucretia's suicide
Oil on lime panel/168 × 74.8/
1518
Munich, Alte Pinakothek

123 The Virgin praying
Oil on lime panel/53 × 43/
1518
Berlin, Staatliche Museen
Preussischer Kulturbesitz,
Gemäldegalerie

119

122

123

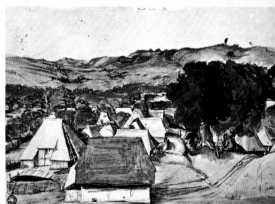

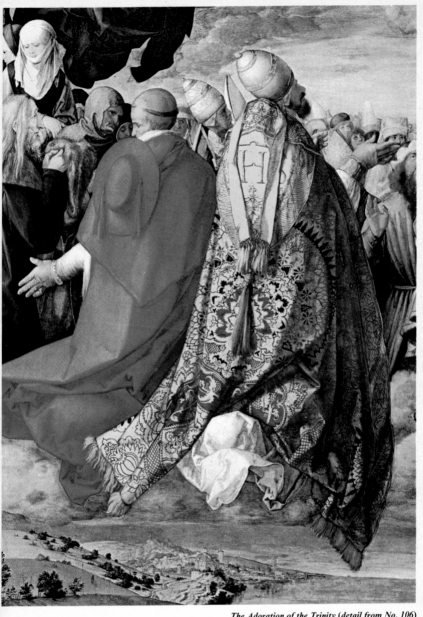

The Adoration of the Trinity (detail from No. 106)
*Among the worshippers at prayer is the figure of
the old benefactor. A cardinal's hand singles him
out and commends him to God and anyone
looking at the picture. Dürer's preliminary profile
portrait drawing exists in the Städelsches
Kunstinstitut in Frankfurt.*

124 Portrait of Jakob Fuggers
Oil on canvas, later mounted on panel/69.4 × 53/1518
Augsburg, Staatsgalerie (Administered by the Bayerische Staatsgemäldesammlungen, Munich)

125 St Anne with the Virgin and Child
Oil on panel transferred to canvas/60 × 49.9/1519
New York, Metropolitan Museum of Art (Altmann Collection)

126 Portrait of Emperor Maximilian I
Oil on canvas/83 × 65/1519
Nuremberg/Germanisches Nationalmuseum

127 Portrait of Emperor Maximilian I
Oil on lime panel/74 × 61.6/1519
Vienna, Kunsthistorisches Museum

128 Portrait of bearded man
Oil on canvas/40 × 30/1520
Paris, Louvre, Cabinet des Dessins

129 St Hieronymus
Oil on panel/59.5 × 48.5/1521
Lisbon, Museu Nacional de Arte Antiga

124

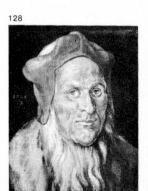

125

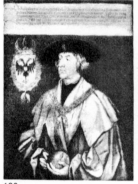

126

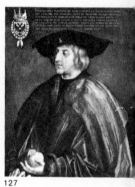

127

128

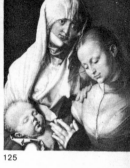

129

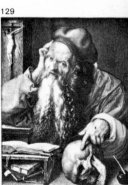

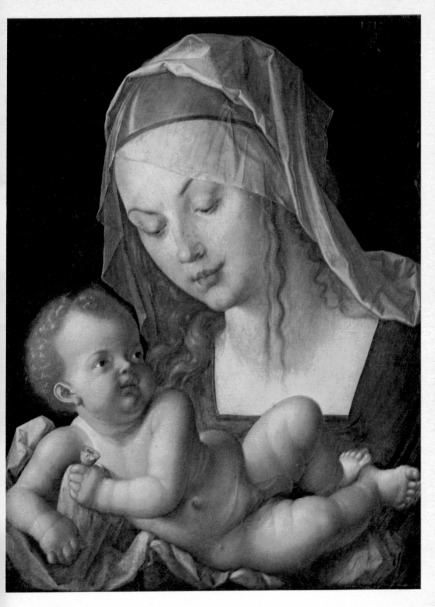

Virgin and Child (No. 107)
*Dürer depicted the Virgin
Mary throughout his life.
Small painted pictures were
intended for personal devotion.
The human bond between
Mother and Child augments the
composition of the picture.*

130d Costume of an aristocratic Livonian lady
Pen drawing on paper with watercolour washes/
18.7 × 19.7/1521
Paris, Louvre (E. de Rothschild Collection)

131d Folk dress in Livonia
Pen drawing on paper with watercolour washes/
19.1 × 20.1/1521
Paris, Louvre (E. de Rothschild Collection)

132d Rich Livonian lady
Pen drawing on paper with watercolour washes/
27.5 × 18.5/1521
Paris, Louvre (E. de Rothschild Collection)

130

131

132

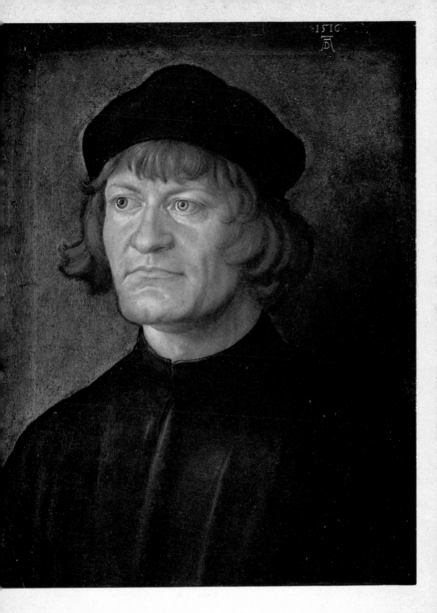

Portrait of a cleric (No. 118)
*It has not been possible to
identify with any certainty the
lively and energetic man whom
Dürer has represented. The
cleric is probably one of the
higher ranking Nuremberg
clergy of the day.*

133 Portrait of an unknown man
Oil on panel/50 × 32/1521
Boston, Isabella Stewart-Gardner Museum

134 Portrait of a young man (Bernhard von Reesen?)
Oil on oak panel/45.5 × 31.5/1521
Dresden, Staatliche Gemäldegalerie, Alte Meister

135d Head of a walrus
Pen drawing with watercolour washes/20.6 × 31.5/1521
London, British Museum

136 Portrait of an unknown man
Oil on panel/50 × 36/1524
Madrid, Prado

137d Albrecht Dürer's Dream
Watercolour on paper/30 × 42.5/1525
Vienna, Kunsthistorisches Museum

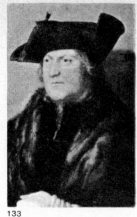

133

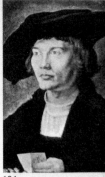

134

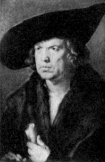

136

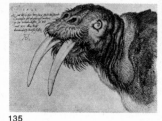

135

137

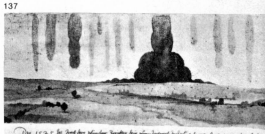

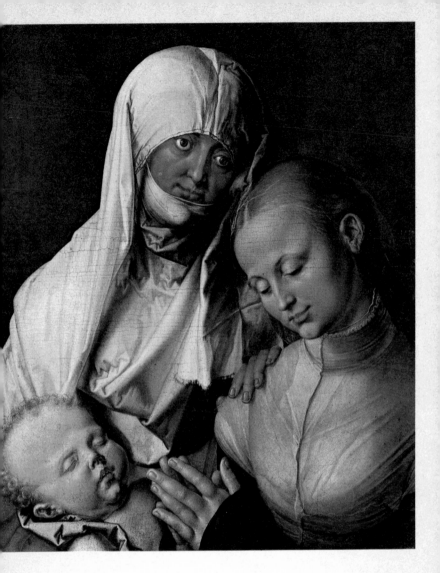

St Anne with the Virgin and Child (No. 125)
The juxtaposition of three generations of the Holy Family – the mother of the Virgin, Mary herself and Christ as a child – is a common theme in German art. The pyramidal composition here, with the folded hands of the Virgin at the centre, makes a powerful and stark unity.

138 Portrait of Jakob Muffel
Oil on panel transferred to
canvas/48 × 36/1526
Berlin, Staatliche Museen
Preussischer Kulturbesitz,
Gemäldegalerie

**139 Portrait of Hieronymus
Holzschuher**
Oil on lime panel/48 × 36/
1526
Berlin, Staatliche Museen
Preussischer Kulturbesitz,
Gemäldegalerie

THE 'FOUR APOSTLES'
140A St John and St Peter
Oil on lime panel/215.5 × 76/
140B St Paul and St Mark
214.5 × 76/1526
Munich, Alte Pinakothek

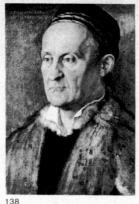
138

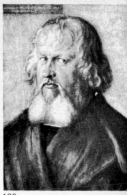
139

140A

140B

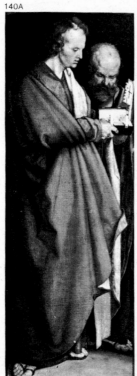

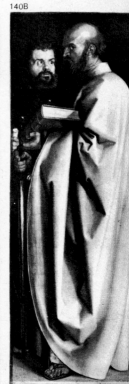

**St Anne with the Virgin and
Child (detail from No. 125)**
*The hand, the artist's tool, so
painstakingly studied in many
of Dürer's drawings was often
used to underline the mood of
a picture.*

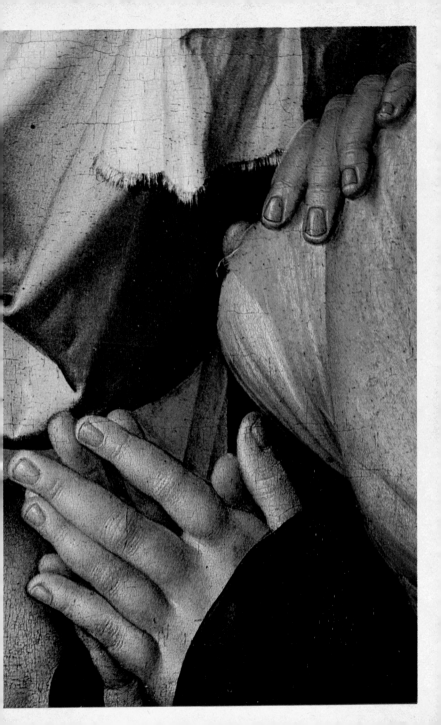

141 The Virgin with the pear
Oil on panel/43 × 31/1526
Florence, Uffizi

142 Portrait of Johannes Kleberger
Oil on lime panel/37 × 36.6/1526
Vienna, Kunsthistorisches Museum

143d Lily
Grisaille – gouache on parchment/9.7 × 11.8/1526(?)
Bayonne, Musée Bonnat

DISPUTED ATTRIBUTIONS; WORKSHOP PAINTINGS; DÜRER IMITATORS

144a The Elevation of the cross
Master from the Hans Pleydenwurff circle
Triptych, centre panel
Oil on lime panel/59.5 × 71.9/
Contemporary copy of an original found by art dealers in 1977
Frankfurt, Städelsches Kunstinstitut

141

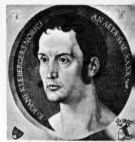

142

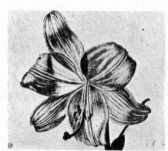

143

144a

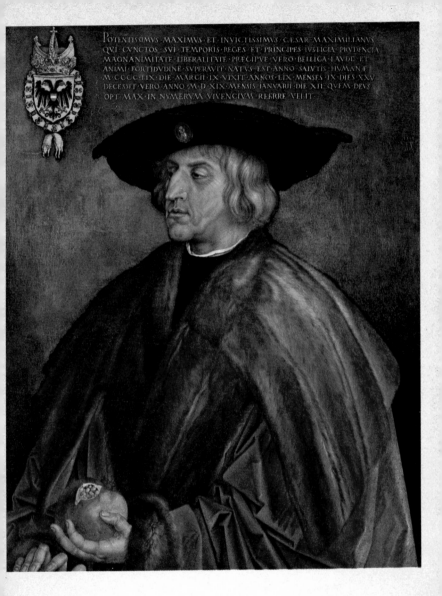

POTENTISSIMVS·MAXIMVS·ET·INVICTISSIMVS·CÆSAR·MAXIMILIANVS
QVI·CVNCTOS·SVI·TEMPORIS·REGES·ET·PRINCIPES·IVSTICIA·PRVDENCIA
MAGNANIMITATE·LIBERALITATE·PRÆCIPVE·VERO·BELLICA·LAVDE·ET
ANIMI·FORTITVDINE·SVPERAVIT·NATVS·EST·ANNO·SALVTIS·HVMANÆ
M·CCCC·LIX·DIE·MARCII·IX·VIXIT·ANNOS·LIX·MENSES·IX·DIES·XXV
DECESSIT·VERO·ANNO·M·D·XIX·MENSIS·IANVARII·DIE·XII·QVEM·DEVS
OPT·MAX·IN·NVMERVM·VIVENCIVM·REFERRE·VELIT

**Emperor Maximilian I
(No. 127)**
*Dürer drew the Emperor, who
had given him many
commissions, at the Imperial
Diet in Augsburg in 1518.
After the Emperor's death the
following year, he used this as
a basis for producing a
woodcut and other portraits.*

145

146

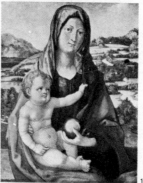

147

148

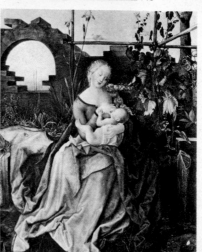

149

St Hieronymus (No. 129)
*The old man's head is based on
a portrait of an 89-year-old
man whom Dürer met in
Antwerp. The amazing realism
of the picture had a dramatic
effect on Netherlandish
painting.*

*WINGS OF ALTAR
PICTURE OF ST THOMAS
FROM THE DOMINICAN
CHURCH IN FRANKFURT*
Albrecht Dürer's workshop
150 Two magi
Oil on pine panel/96 × 60/
Frankfurt, Historisches
Museum

*151 Portrait of a man (St
Hieronymus?)*
Oil on panel/33.2 × 25.6/
Siena, Pinacoteca Nazionale

152 Salvator mundi
Oil on panel/19.5 × 17.5/1514
Formerly Bremen, Kunsthalle
Bremen

*153 Portrait of a man (Hans
Schäufelein?)*
Oil on panel/39.5 × 32.5/
Berlin, Staatliche Museen
Preussischer Kulturbesitz,
Gemäldegalerie

*154 Portrait of a woman in
Netherlandish costume (wife of
Jobst Planckfelt?)*
Oil on panel/31.5 × 26.8/
1521(?)
Toledo, Museum of Art

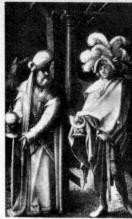

150

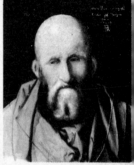

151

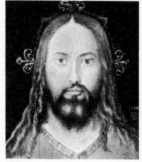

152

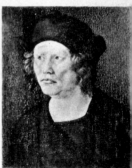

153

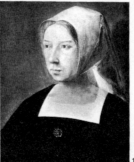

154

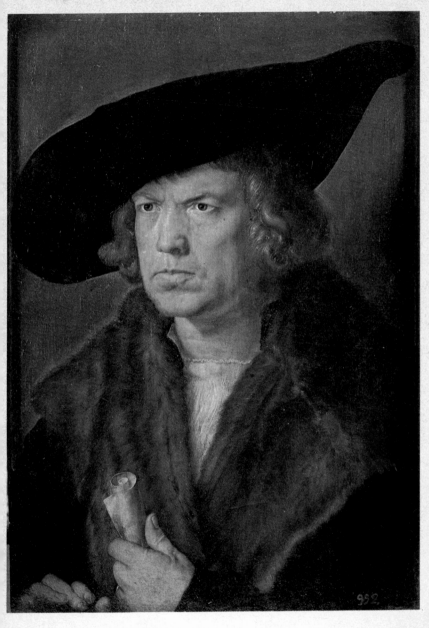

Portrait of a man (No. 136)
The vigorous and self-confident sitter for this portrait has not yet been identified. He may have been one of the noblemen who took part in the Nuremberg Imperial Diet of 1522–3.

155d Lion striding to the left
Watercolour and gouache on parchment/17.7 × 28.8/ 1521(?)
Vienna, Graphische Sammlung Albertina

156d Lion striding to the right
Pen drawing, coloured with grey wash/16.8 × 25/1521(?)
Formerly Vienna, Fräulein Dora Breuer Collection

157 Portrait of a mathematician
Technique and size unknown
Milan, Borromeo Collection

158 Salvator mundi
Unfinished with later alterations
Oil/53 × 43/c.1526
New York, Art dealer

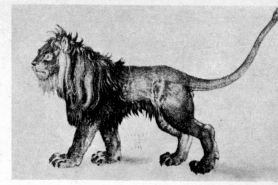

155

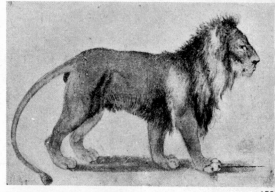

156

The 'Four Apostles'
(No. 140A-B) (p. 93)
Dürer presented these two wing pictures of SS. John and Peter and SS. Paul and Mark to the City Council of his home town, so that they could be kept in the Town Hall.

St Mark, the Evangelist
(detail from No. 140B) (p. 94)
The choice of the four saints, of whom Mark was the only one not an apostle, was probably determined by the text reproduced below the figures and intended to be pertinent to the citizens of Nuremberg.

The book held by St John
(detail from No. 140A) (p. 95)
Though the text on the open page is not readable it is clear that it is lettering and not printing. The text at the bottom of the panel uses Luther's translation which appeared in 1522.

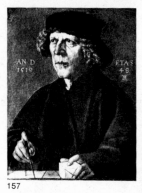

157

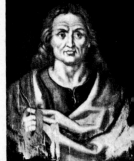

158

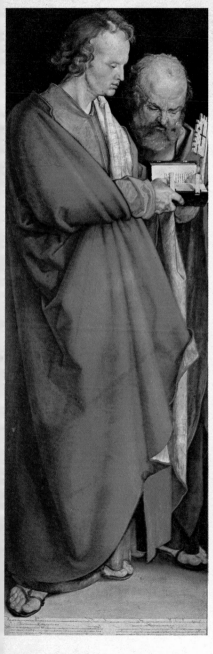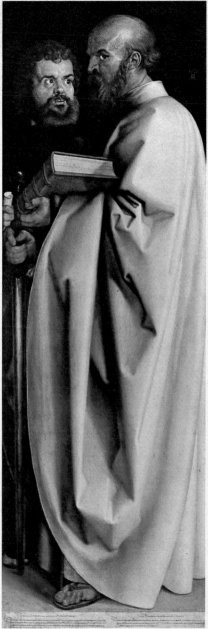

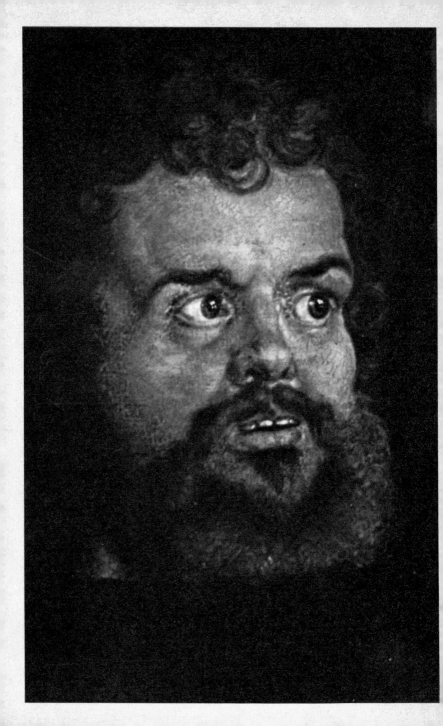

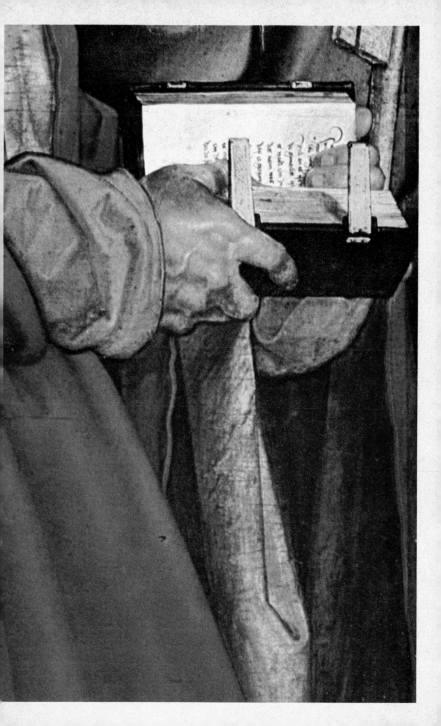

Bibliography

MATTHIAS MENDE: *Dürer-Bibliographie*. (2 vols.) Wiesbaden 1971.

FEDJA ANZELEWSKY: *Albrecht Dürer. Das malerische Werk*. Berlin 1971.

KRISTINA FIORE-HERRMANN: 'Das Problem der Datierung bei Dürers Landschaftsaquarellen', in *Anzeiger des Germanischen Nationalmuseums 1971–2*, pp. 122–42.

EDUARD FLECHSIG: *Albrecht Dürer. Sein Leben und seine künstlerische Entwicklung*. (2 vols.) Berlin 1928–31.

HANS JANTZEN: *Dürer der Maler*. Berne 1952. .

WALTER KOSCHATZKY: *Albrecht Dürer. Die Landschafts-Aquarelle. Örtlichkeit, Datierung, Stilkritik*. Vienna-Munich 1971.

WALTER KOSCHATZKY, Alice Strobel: *Die Dürer-zeichnungen der Albertina*. Salzburg 1971.

ERWIN PANOFSKY: *Albrecht Dürer*. (2 vols.), 3rd edition. Princeton 1948.

ERWIN PANOFSKY: 'Des Leben und die Kunst Albrecht Dürers', in *Deutsche übersetzt von Lise Lotte Möller*. Munich 1977.

Dürer. Schriftlicher Nachlass. Hrg. v. Hans Rupprich. (3 vols.) Berlin 1956–69.

WALTER L. STRAUSS: *The Complete Drawings of Albrecht Dürer*. (6 vols.) New York 1974.

HANS TIETZE, ERIKA TIETZE-CONRAT: *Kritisches Verzeichnis der Werke Albrecht Dürers*. (2 vols.) Augsburg 1928; Basel-Leipzig 1937–8.

PIERRE VAISSE, ANGELA OTTINO DELLA CHIESA: *Das gemälte Werk von Albrecht Dürer*. Lucerne, Freudenstadt, Vienna 1972.

FRIEDRICH WINKLER: *Dürer. Des Meisters Gemälde, Kupferstiche und Holzschnitte. Klassiker der Kunst*. (4th edition) Berlin-Leipzig 1928.

FRIEDRICH WINKLER: *Die Zeichnungen Albrecht Dürers*. (4 vols.) Berlin 1936–9.

FRIEDRICH WINKLER: *Albrecht Dürer. Leben und Werk*. Berlin 1957.

First published in the United States of America 1980 by Rizzoli International Publications, Inc.
712 Fifth Avenue, New York, New York 10019
Copyright © Rizzoli Editore 1979
This translation copyright © Granada Publishing 1980
Introduction copyright © Sir Ellis Waterhouse 1980
ISBN 0-8478-0267-1
LC 79-64903
Printed in Italy